To David, Christine
and Family.

all the best!

# Boston
## an extended family

PHOTOGRAPHS BY BILL BRETT

*Text by* CAROL BEGGY • *Foreword by* DORIS KEARNS GOODWIN

COMMONWEALTH EDITIONS • BEVERLY, MASSACHUSETTS

ISBN: 978-1-933212-38-8

**Library of Congress Cataloging-in-Publication Data**
Brett, Bill, 1945-
   Boston : an extended family / photographs by Bill
Brett ; text by
Carol Beggy ; foreword by Doris Kearns Goodwin.
      p. cm.
   Includes index.
   ISBN-13: 978-1-933212-38-8 (alk. paper)
   1. Boston (Mass.)--Biography--Portraits. 2. Boston
(Mass.)--Biography. 3. Celebrities--Massachusetts--
Boston--Portraits.
4. Celebrities--Massachusetts--Boston--Biography. 5.
Portrait
photography--Massachusetts--Boston. I. Beggy,
Carol. II. Title.
   F73.25.B84 2007
   974.4'610430922--dc22
                                          2007015333

Cover and interior design by Stephen Bridges

Printed in China

Commonwealth Editions
266 Cabot Street
Beverly, Massachusetts 01915
www.commonwealtheditions.com

*Jacket photo:* All the living inhabitants of the corner
office in the Massachusetts State House, and one who
soon would report for work there, gathered in the
shadow of the golden dome to have their photograph
take as Mitt Romney's administration was in its last
weeks. From left: William F. Weld, Deval Patrick,
Michael S. Dukakis, Jane M. Swift, Paul Cellucci,
Mitt Romney.

# FOREWORD

Through these remarkable photographs, the spirit and the people of Boston are brought to vivid life. With an astonishing feel for drama, detail, and depth, Bill Brett takes us on a journey through time, blending the past with the present, mingling events of everyday life with memorable moments. It must not have been easy for Brett to choose from thousands upon thousands of photographs those that would best provide a chronicle of his beloved Boston. Yet, with the help of Carol Beggy's rich commentary which provides the stories behind the images, Brett has produced a book that will have an enduring attraction.

It is fascinating to see the range of approaches Brett brings to his subjects. Some are shown in formal attire; others in their work places; still others in unusual settings.

There are celebrities of course—Patriot quarterback Tom Brady standing at a podium, so dignified in suit and tie that he looks as if he were about to deliver an acceptance speech at a political convention; Yo-Yo Ma revealing in every line of his face the passion he brings to his music; Walter Cronkite with an amused expression on his familiar face as he participates in a charity auction on Martha's Vineyard. We see the first female president of Mount Auburn Hospital, the first female president of MIT, the first woman in over 30 years to serve as president of the Boston City Council.

The images portray the dramas that captured our imagination—the marriage of two gay men who had courted one another for fifty years; the disappearance of Molly Bish; the bloody sock that helped to win the Sox World Series. But Brett also reveals ordinary people who have done extraordinary things. We see one family that has produced three generations of mayors for the city of Cambridge; another family where four sons have followed their father into dentistry; eleven brothers from Southie; three restaurant owners boasting a hundred years of restaurant service among them.

We see time passing—the Littlest Bar before it was torn down; Jimmy Kelly before he died; and the funeral service for Governor Ed King.

It is the composition of the photos that arrests our attention—Fiedler's son posed next to the bust of his father; the long neck of a giraffe kissing the president of the Franklin Park Zoo; the elegant, graceful hands of John Updike; the black and white floor of the convent now converted to a shelter for families and young children in transition. Individually worthy of concentrated attention, taken together these photos capture the essence of a city that has preserved so much of its past while remaining open to growth and change. This collection is a triumph.

*Doris Kearns Goodwin*
*May 2007*

As the story goes, the tiny, floundering radio station WWEL in Medford hired a hotshot young radio programmer, **Richie Balsbaugh,** in 1978. The station changed its call letters to WXKS (or simply Kiss 108), changed its format to keep up with the trends in popular music, and vaulted from worst in the ratings to the powerhouse it's been for the last 25 years. In 1982, Richie bought Kiss 108 and created his Pyramid Communications, using the success and innovations he developed in Boston to expand his operations. In 1996, Pyramid capitalized on the deregulation of the radio industry, selling its 12 stations around the country to what is now Clear Channel. That wasn't the end of Richie's involvement in the music biz. In 2005, he and Steve Rivers founded Pyramid Radio Inc., a new-media company that provides custom music formats and advertising in retail settings. Throughout his many incarnations, this businessman with a rock 'n' roll heart has remained a constant on Boston's charitable scene and a regular contributor to many of the biggest events on the annual civic calendar.

One thing about actor **Ben Affleck**, he's not a fair-weather friend. A full year before the Red Sox had their World Series trophy, the Oscar-winning writer had publicly acknowledged his love for the Hometown Team by paying $50,000 for the No. 1 license plate to benefit the Jimmy Fund, a Red Sox charity. In the summer of 2006, Affleck brought his wife, actress Jennifer Garner, and their baby girl, Violet, to Boston where he filmed his first project as a director, based on Dennis Lehane's *Gone, Baby, Gone*. And while he stayed away from Fenway while working on his first flick in the director's chair, it was a different story during 2004's Democratic National Convention in Boston, when this photo was taken.

After years of success at his family's Brookline restaurant, Veronique, **Jim Apteker** turned his attention to transforming the celebrated eatery into event space and to opening new venues in the city. We can't think of a better-timed entry into the local marketplace. Jim opened the State Room in the former Bay Tower Room just as the Democratic National Convention was starting in Boston. His first event in the new venue featured former President Bill Clinton; his wife, Senator Hillary Clinton; and their daughter, Chelsea. Jim's Longwood Events regularly donates its luxe spaces to help out local nonprofit groups.

**Barbara Anderson** has been looking at the public bottom line for more than three decades. She is the executive director of Citizens for Limited Taxation, which was founded in 1974 to "defend state taxpayers against a proposed state graduated income tax," a measure the organization defeated in a statewide ballot in 1976 and again in 1994. Barbara, who spearheaded the 1980 passage of Proposition 2½, which limits municipal property taxes, is an outspoken advocate for Massachusetts taxpayers—whether you want her to be or not. A regular on the talk radio circuit, Barbara is a prolific writer and a fierce critic of any perceived squandering of the public's money.

**Sheldon Adelson** and Nobel laureate **Eli Wiesel** have not forgotten where they came from or the price paid for the freedoms and successes they now enjoy. Sheldon got his start in business as a 12-year-old selling newspapers on a Dorchester corner. Now chairman and majority owner of Las Vegas Sands, Inc., he parlayed his convention and trade show company, The Interface Group, into one of the world's largest casino operations. He's ranked as the sixth richest person in the world, but also is considered to be among the most philanthropic. A survivor of Auschwitz, Eli is the founding chairman of the US Holocaust Memorial Council and chairman of The Elie Wiesel Foundation for Humanity, an organization he and his wife created to fight indifference, intolerance and injustice. Since 1976, he has been the Andrew W. Mellon Professor in the Humanities at Boston University and travels the world speaking about the Holocaust.

Fans of sports talk-radio know **Eddie Andelman** for his 35 years on the airwaves, including his latest effort on FM station WTKK with "Sports Huddle" on Sunday nights. Careful listeners know that Eddie is a foodie —albeit a regular-guy type of food lover—who will pepper his sports observations with restaurant suggestions. In 1990, after declaring that the hot dog was "the ultimate sports food," Eddie merged all his passions and founded the Hot Dog Safari, an annual gathering that raises money for the Cystic Fibrosis Foundation's Joey Fund, which seeks to find a cure for the disease.

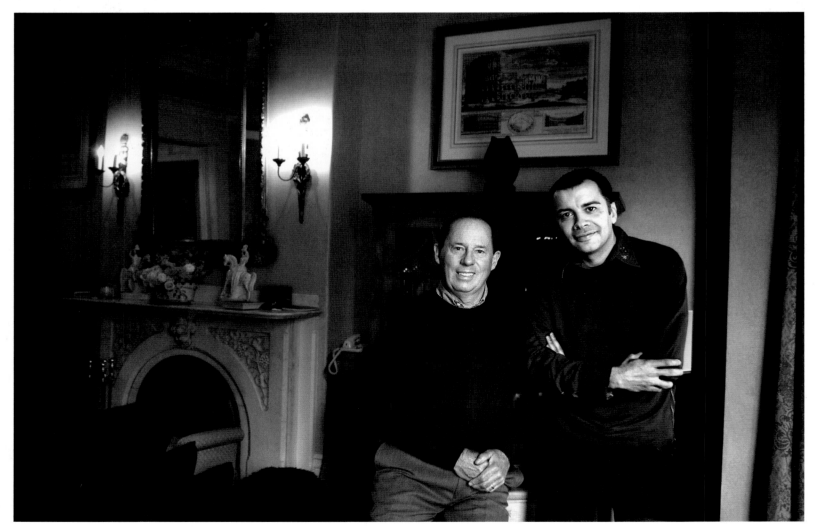

**John Archibald** and **James Costa** work on behalf of their community, to promote literacy and to improve the environment and the treatment of animals. John has lived for 12 years on Union Park in Boston's South End, where he has become active in the community. It was quite a change for this former diplomat who spent most of his career in Africa managing American cultural centers and educational exchange programs. James is a writer, producer, and animal welfare advocate, with a passion to bring together the issues of the environment and the treatment of animals and how they both must be respected for the earth to remain healthy.

The members of the **Ancient and Honorable Artillery Company of Massachusetts** strive to be just that: they are honor-bound to preserve the region's rich military history. Dating back to 1638, the group was organized as a militia for the young Massachusetts Bay Colony. It is the oldest chartered military organization in the Western Hemisphere and believed to be the third oldest chartered military organization in the world. With a motto of "Deeds Not Words," the Company is part of many of the state ceremonies, events and parades held each year. One duty they've never missed is the inauguration of a new governor, which is what brought them together for this photograph in January 2007 where **Captain Daniel G. May,** then–Captain Commanding, led the group in a day of events. For the portrait, the Company was joined by three members of the National Lancers, pictured behind Captain May.

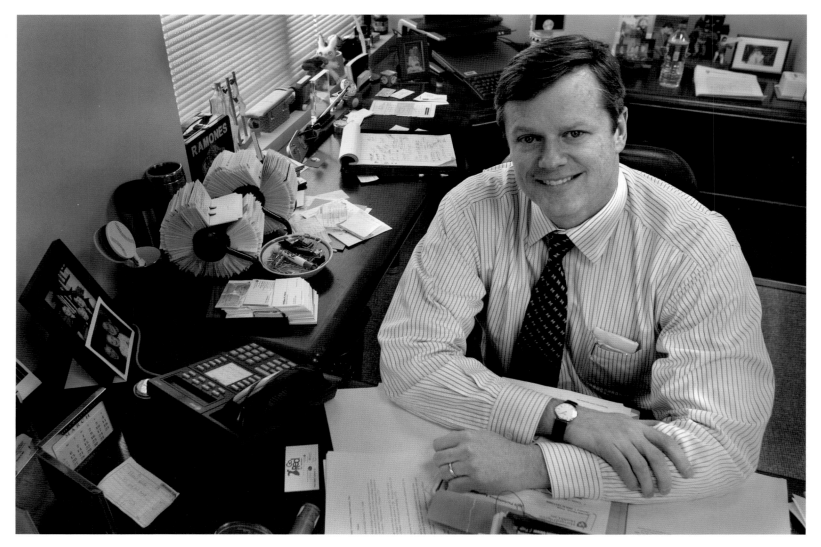

President and CEO of Harvard Pilgrim Health Care, Inc., **Charles D. Baker** leads one of New England's leading nonprofit health plans, serving one million members in Massachusetts, Maine, and New Hampshire. While you can take the administrator out of the political fray, you can't take politics out of Charlie. He served as secretary of administration and finance and secretary of health and human services under Governors William Weld and Paul Cellucci. Charlie is talked about as a possible gubernatorial candidate. In April 2007, he ended his service as a selectman in the town of Swampscott.

A commanding figure for more than 17 years at WCVB-TV Channel 5, where he invented "Chronicle" and put Chet Curtis and Natalie Jacobson together on the anchor desk, **Philip S. Balboni** has received every major television journalism award. But founding New England Cable News in 1992 is among his greatest accomplishments. NECN is the nation's first and largest 24-hour regional news station, whose public affairs programming, long-form stories, documentaries, and business and lifestyle shows make it an intellectual standout in a world of sound-bite journalism. NECN has nearly four million subscribers, and is seen in 1,037 cities and towns across New England.

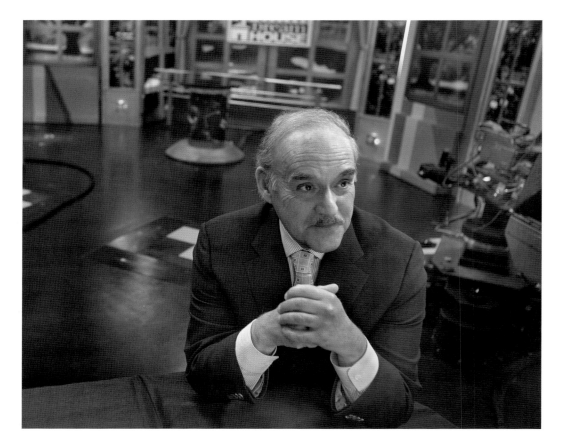

They are both leaders in Boston's legal community, but **Paul J. Ayoub** and his brother **Joseph S. Ayoub Jr.** seem to be as well-known for their civic commitments. Paul, who is a partner at Greenberg Taurig, focuses primarily on commercial real estate development and finance. Joe's practice concentrates on civil litigation, particularly business cases, and has represented clients in more than 300 bench trials. These brothers support a host of charitable causes. Both serve as board members of the St. Jude Children's Research Hospital in Memphis, Tennessee; Big Brothers Big Sisters of Massachusetts Bay; and the Greater Boston Chamber of Commerce.

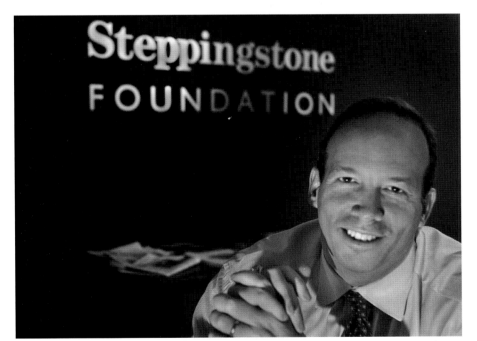

It was his own high-quality education that crystallized **Michael P. Danziger**'s life mission. Those young people, particularly inner-city youths, who are cut off from the best education programs face setbacks from which they may never recover. To address this injustice, Michael co-founded the Steppingstone Foundation in 1990. Today, the not-for-profit program has helped thousands of kids in Boston, Hartford and Philadelphia gain access to higher education. Michael admits that when he started he faced a few problems: He had no entrepreneurial experience and he had few contacts in Boston. But he was spurred on by the achievements of the young Steppingstone Scholars, who participate in the 14-month program to get them on the track to a college education.

As the Red Sox opened the 2007 season, there was a deep, city-block-long hole in the ground on Boylston Street just steps from Fenway Park. While most passersby could only see what wasn't there, Fenway Community Health Center's board chair **Joanne T. Ayoub,** director of Organizational Development at Beth Israel Deaconess Medical Center, and president and CEO **Dr. Stephen Boswell, MD,** could only see the promise of what was to come. When it opens in 2009, the 100,000-square-foot, 10-story building will be the largest health facility in the United States with a mission to serve the lesbian, gay, bisexual and transgendered communities.

When their 16-year-old daughter Molly was abducted on June 27, 2000, from Comins Pond, where she worked as a lifeguard for the town of Warren, **Maggie** and **John Bish** were thrust into a spotlight that would have withered most. Even after Molly's remains were found less than five miles from their home nearly three years later, Maggie and John and their tiny central Massachusetts town rallied together. Maggie and John and those who have supported them haven't just been waiting for answers. They established a foundation and the Molly Bish Center for the Protection of Children and the Elderly at Anna Maria College.

They have been friends since the seventh grade when they started at Boston Latin School. **Ron Bell** and **Rev. William E. Dickerson II** are two of Boston's most effective leaders, and they do it by example. Ron is the founder and former executive director of the nonpartisan Dunk the Vote. He worked in Deval Patrick's campaign and now serves as the director of the governor's Public Liaison Office, the primary outreach vehicle for the administration. Bill is pastor of the Greater Love Tabernacle Church in Dorchester, where Ron serves as a deacon. Bill has been a steady voice during some difficult times in the city, using the power of the pulpit and the strength of a community's faith to bring about change.

The public events of September 11, 2001, were a very personal tragedy for **Katherine Bailey**, whose husband, Garnet "Ace" Bailey, was a passenger on United Airlines Flight 175. Yet Katherine wasn't going to let her husband's ebullient spirit be lost because of that devastating day. Her sister, **Barbara Pothier**, joined her in founding the Ace Bailey Children's Foundation, named for the two-time Stanley Cup champion Boston Bruin. The foundation's first project was this 6,500-square-foot play center at the Floating Hospital for Children at the Tufts–New England Medical Center, called Ace's Place.

Although **Dr. David M. Barrett, MD**, is the president and CEO of Lahey Clinic in Burlington, this specialist in urology continues to teach and work as a physician. And he's overseeing a recently announced $50 million expansion project that will add 63,000 square feet to Lahey's Northshore Mall clinic. Before coming to Lahey in 1999, David was a physician, teacher and administrator at Mayo Clinic in Rochester, Minnesota. He served as a flight surgeon during the Vietnam War and was chief of the Aeromedical Service at Cam Ranh Bay Air Base.

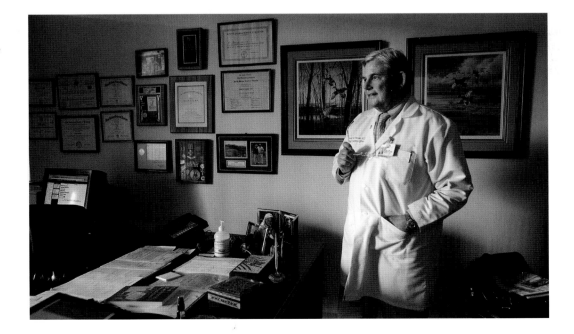

In 1960, **Ronald E. Burton** was the first player drafted by the newly formed Boston Patriots of the American Football League. Both during his playing time with the Patriots and later working in public relations as a motivational speaker and coach, Ron drafted the Boston area and its residents as his own. On the field, it didn't take Ron long to have an impact and some of his records were still standing at the end of the 2006 season. Plagued by serious back injuries, Ron's NFL career lasted only through the 1966 season. In 1985 he bought more than 300 acres in Hubbardston for his Ron Burton Training Village, which hosts a five-week camp for 11- to 17-year-old young men, most of whom receive full scholarships.

The bright red jackets, khaki pants, and Timberland boots are a familiar sight in Boston these days. But in 1988 when **Michael Brown** and **Alan Khazei** founded City Year it was just a dream of these then-roommates at Harvard Law School that young people would create teams to change their communities rather sit back while others destroy them. In April 2007, City Year had enlisted more than 1,200 young adults in 16 communities across the country and in Johannesburg, South Africa. Michael is CEO and served as president of the organization until 2006. Alan is a social entrepreneur who has helped bring the entrepreneurial ideas of the private sector to civic endeavors.

With more than 31 million books in print, **Jan Brett** is one of the nation's foremost author/illustrators of children's books. Jan, who is no relation to Bill Brett, is married to **Joseph Hearne,** who plays the double bass with the Boston Symphony Orchestra. That's the instrument played by the title character in *Berlioz the Bear,* which she wrote with Joseph in mind. The couple didn't meet through music or books, Jan notes on her website; they met because they both love to fly and Jan still loves to go gliding. They are regulars on the social and philanthropic circuit, attending as many events as their schedules allow.

A three-time Super Bowl champion who twice has earned MVP honors for professional football's biggest game, New England Patriots quarterback **Tom Brady** knows what it is to be at the top of his game. But when he spoke at this City Year event in 2006, it was to the young people in the famous red jackets who were working in the communities trying to make a difference that Tom directed his remarks. As a backup quarterback in his early days at the University of Michigan, Tom said he worked hard through long practices to become a team co-captain and lead his team to an Orange Bowl victory in 1999. Drafted by the Patriots in the sixth round, Tom told the City Year participants that he continued to work hard in case he got a shot at playing in the NFL, which he did in 2001 when the Patriots went on to win their first Super Bowl title.

Trains from Forest Hills once shook Doyle's Cafe as they roared on their way to Oak Grove along the elevated Orange Line. The tracks are long gone and Doyle's has become a community haven on Washington Street in Jamaica Plain. The storied pub is now run by partners **Jerry Burke Jr.**, **Jerry Burke Sr.** and **Chris Spellman**. Jerry Sr. is a walking repository of electoral lore, political shenanigans, and neighborhood nuances. Politicians, artists, blue collar workers, and suit-wearing Financial District types flock to Doyle's for good food served with a laugh and a side of old-fashioned Boston gossip.

To gauge how big an impact documentarian **Ken Burns** has had over his 25 years of bringing history to life on film, one need only look at the closest Apple computer. When the company put out an easy-to-use software program for home movie making, it named one of its effects after Ken. Never one to shy away from controversy, Ken still finds a way to enjoy large audiences on public television for his all-encompassing depictions of *Baseball*, *The Civil War*, or *Unforgivable Blackness: The Rise and Fall of Jack Johnson*. Twice nominated for an Academy Award for his work—*Brooklyn Bridge* and with Buddy Squires for *The Statue of Liberty*—Ken is known for mining archival materials and infusing old photographs, newspaper clippings, ephemera and everyday notes and correspondence with a vibrancy that entertains as well as informs.

**Bruce A. Beal** and **Robert L. Beal** (with Mountie, Too) are the fourth generation of their family to run the real estate investment firm The Beal Companies. And while they've followed on a proud path charted for them, these brothers have made some of their own history too. In the late 1960s, Bruce was the first to bring condominiums to the market with a project on Memorial Drive in Cambridge. In the 1980s, the brothers pioneered the development of life science projects in Cambridge and Lexington. And in the 1990s, they worked with the Marriott Corp. to save the historic Custom House. The Beals actively and generously support the arts and civic organizations in the area.

Boston's Museum of African American History doesn't just tell about the past, as New England's largest institution dedicated to preserving and interpreting the contributions of African Americans. Integral to the museum's mission is the celebration of the future, according to Executive Director **Beverly A. Morgan-Welch**. To that end, the museum hosts the presidents of color running Boston-area colleges including **Dr. Carole M. Berotte Joseph** of MassBay Community College, the first Haitian-American to run a US college; **Dr. Linda Edmonds Turner**, Urban College of Boston; **Dr. Dana Mohler-Faria**, Bridgewater State College; and **Dr. Terrence A. Gomes**, Roxbury Community College.

**Ron Bersani** turned a grandfather's grief into a State House crusade that resulted in one of the toughest drunken-driving laws in the country. Bersani's granddaughter Melanie Powell was just 13 when she was killed by a repeat drunken driver on July 25, 2003. It was about six months later when Ron and Melanie's parents, Tod and Nancy Powell, were speaking to a sixth-grade DARE graduation at Melanie's former school in Marshfield that the grandfather decided to take action. That began a year of lobbying that brought politicians and organizations from all political viewpoints together on October 28, 2005, to witness Melanie's Law being signed into effect.

Founder of the private equity firm Advent International Corp., **Peter Brooke** has more than 40 years of banking and venture capital experience in the US, Europe, Asia and other international markets. He began his career as a lending officer at the First National Bank of Boston, where he founded the High Technology Lending Group. He is a member of the Private Equity Hall of Fame and a recipient of Harvard Business School's Alumni Achievement Award. He is also a Fellow of the American Academy of Arts and Sciences, and is a member and former chairman of the Boston Symphony Orchestra's board of trustees.

They are a proud bunch at the South Shore Savings Bank, with a track record to back them up. **Arthur R. Connelly**, chairman and CEO of the bank's holding company, South Shore Bancorp, as well as chairman of the bank, and **John Boucher**, president and CEO of the bank, will point out that they run a mutually owned, locally controlled financial institution. It's something all too rare these days. Not beholden to investors, this savings bank touts its mission of serving its customers. But they are most proud of the South Shore Savings Charitable Foundation, which makes grants in the communities it covers to improve the quality of life for its residents.

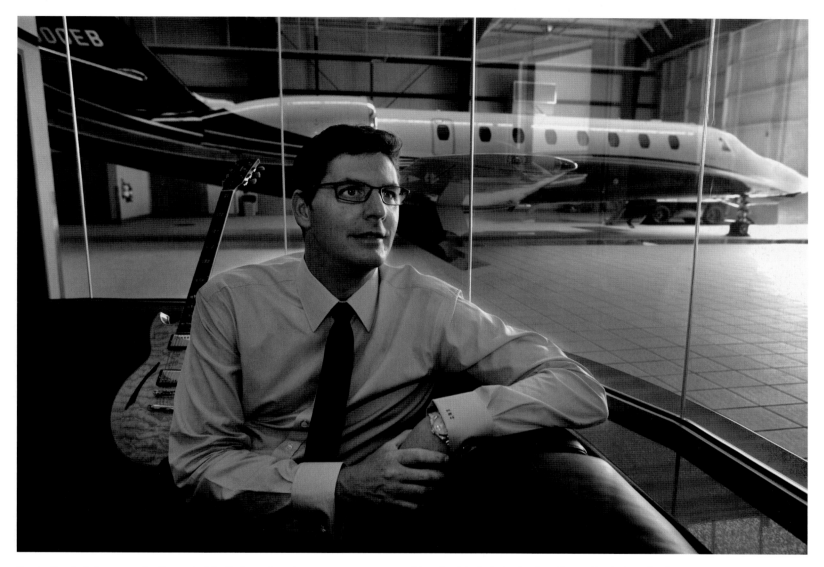

**Ernie Boch Jr.**'s career in the auto biz began when he was a teenager working for his father, the late Ernie Boch Sr., the "Come On Down!" icon of New England's automotive industry. This president and CEO of Boch Automotive Enterprises in Norwood is also known in the region for his work off the auto lots that bear the family's name. A musician at heart, Ernie graduated from the Berklee College of Music, where he's on the board, and runs "Music Drives Us," a Boch family foundation he created to support music education. Ernie often lends the use of his Cessna Citation Sovereign jet, shown here in the private hangar in Norwood, to charities for quick, private travel.

Sworn in for his second term on January 17, 2007, **Timothy P. Cahill** serves as the state's treasurer and receiver general. As the Commonwealth's CFO, Tim oversees the state's pension system, the school building authority, the lottery, and a host of veterans' benefits, and is charged with trying to return abandoned property or money to those who may not know they have lost it. Before he was elected to office in 2002, Tim was Norfolk County's treasurer and a Quincy city councilor. A former small business owner and author, the Boston University graduate is among nine government officials chosen nationally for a 2007 Eisenhower Fellowship.

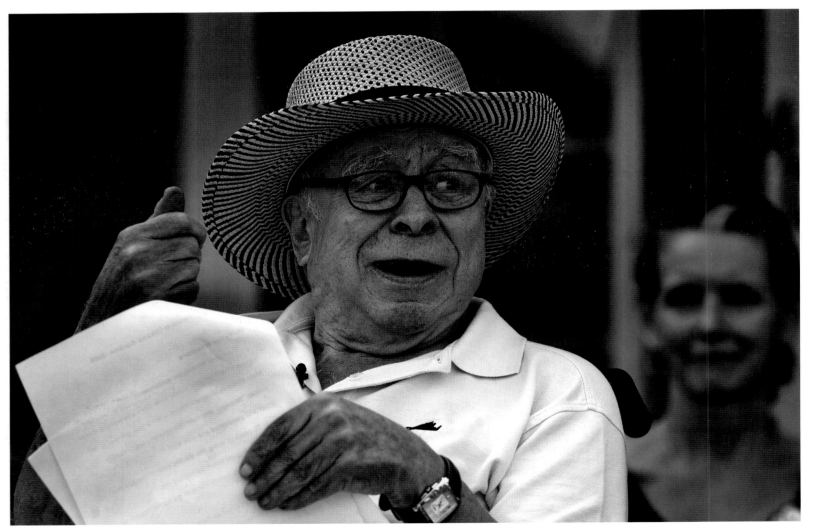

It's only fitting that political satirist and long-time newspaper columnist **Art Buchwald** would have the last word. Well, several of them. When Art died in January 2007, he had already written his final column and recorded a video version of an obituary for *The New York Times* in which the writer says, "Hi. I'm Art Buchwald, and I just died." In early 2006, Art checked himself into a Washington, D.C., area hospice because his kidneys were failing and the doctors said he had just a short time to live. But by the summer of 2006, Art was well enough to return to Martha's Vineyard one last season and resume his post as auctioneer for an annual fundraiser he championed.

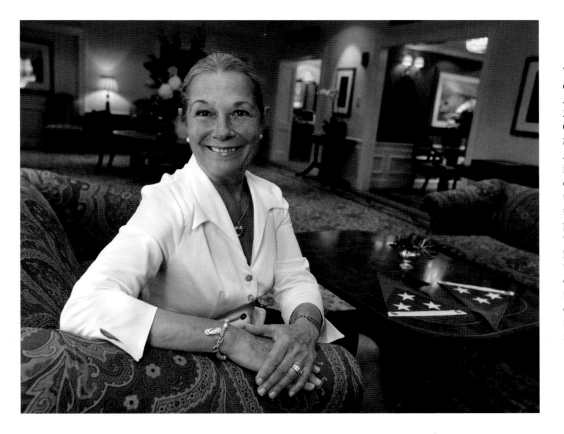

The ALLY Foundation was born out of the tragic, preventable murder of Alexandra Nicole Zapp on July 18, 2002. Her mother, **Andrea M. Casanova**, and step-father, Steven Stiles, took their direction from Ally's life: to make change in an intelligent, creative manner. The couple, who moved to Boston from the West Coast to run the foundation, work to get national legislation passed to change how society deals with sex offenses. They've already picked their next goal: to become the national voice for the prevention of sex offenses. Andrea, the foundation's co-founder and executive director, said, "We want her to be remembered for the way she lived, not the way she died."

They founded Urban Improv, the interactive program for young people that uses improvisational theater to teach violence prevention, conflict resolution and decision-making, in 1992 at a time when Boston's youth was affected by violence in staggering numbers. Urban Improv's supporters have raised hundreds of thousands of dollars and helped thousands of young people. Annually, they hold Banned in Boston, where the theatrical skills of some of Boston's biggest players are tapped to keep the program thriving. The founders are the program's executive director, **Kippy Dewey,** seated; and clockwise, **Susan Cohen;** the program's managing director, **Narcissa Campion; Candy Walton; Lisa Schmid Alvord,** president of the board of advocates; **Ann Hall;** and **Toby Dewey,** artistic director.

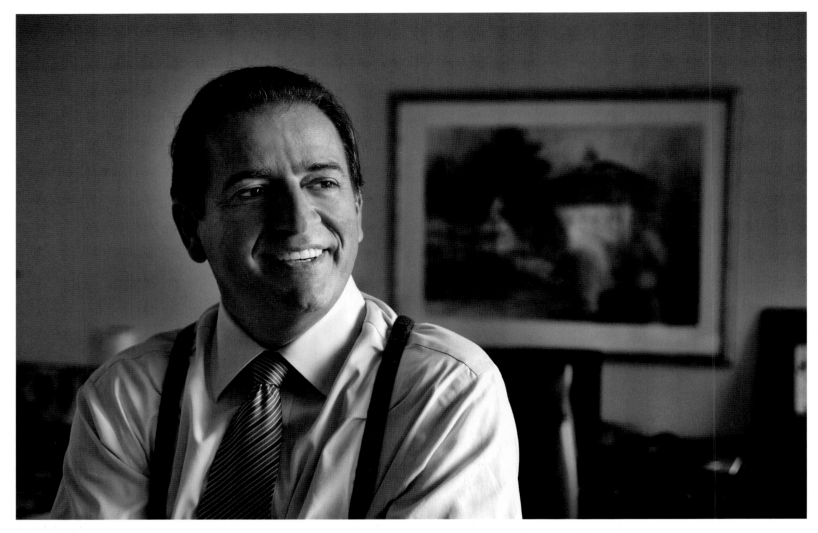

**Joseph P. Campanelli** is president and CEO of Sovereign Bank and Sovereign Bancorp Inc., a $90-billion financial institution serving two million households across the Northeastern part of the country. Joe is a veteran of the New England banking business who spent 20 years serving in a variety of executive positions with both Fleet and Shawmut Bank before joining Sovereign in 1997 as president and COO of Sovereign Bank New England. An active member of the community, he is chairman of the Massachusetts Business Roundtable, a non-profit, nonpartisan, statewide public affairs organization of CEOs representing Massachusetts's leading industry and business enterprises and chairman of the board of trustees for Tufts–New England Medical Center.

This Beacon Street rooftop is just two blocks from the spot where **Mike Casey** proposed to **Lisa Hughes** in 2004—about a year and a half after friends set them up on a blind date. A year later, they married in her home state of Idaho. An award-winning journalist, Lisa arrived in Boston in 2000 to follow Liz Walker as the lead female anchor at WBZ-TV. A Taunton native, Mike left a 12-year career in advertising to follow his passion for photography. Now a freelance photographer, Mike assisted Bill Brett with this book. Both are dedicated to the city and support several organizations, including Children's Hospital and City Year.

Francis X. Flaherty Sr. is as proud of his family's accomplishments as he is of his own. An attorney who practiced law for more than 45 years and will mark 45 years of marriage with wife Maureen in 2007, he was twice elected a Middlesex County commissioner. Son **Francis X. (Chip) Flaherty Jr.**, is executive vice president and general counsel of Walden Media and former assistant attorney general of Massachusetts. **Peter G. Flaherty II** is deputy campaign manager of Romney for President, former deputy chief of staff for Governor Mitt Romney, and a Suffolk County prosecutor. And **Micheal K. Flaherty** is president and co-founder of Walden Media, producers of *The Chronicles of Narnia: The Lion, the Witch and the Wardrobe* and many other family-friendly education-oriented films.

You won't often read about **Charles M. Campion, Charles A. Baker III** or **Michael Whouley,** but you often hear about their clients. And these founders of the Dewey Square Group wouldn't have it any other way. After years of friendship and working in the political arena, they came together in 1993 to form the Dewey Square Group, which applies campaign-style strategies and tactics to private-sector challenges. Chuck Campion served as special assistant to Vice President Walter Mondale and has worked for the Democratic National Committee. An attorney, Charlie Baker served as a senior advisor on national field strategy to Kerry/Edwards 2004 and the Democratic National Committee. Michael has been a key strategist in many high-profile national public policy debates. He was also widely recognized as the National Field Director for the Clinton/Gore '92 presidential campaign, and later as National Campaign Manager for Vice President Gore during the 1996 reelection.

**Walter Cronkite**, who was famously voted the "most trusted figure" in America, is revered for his fair and impartial reporting of the day's events from the anchor desk of the "CBS Evening News." But it is for those rare breaks in his newsman's facade that the award-winning journalist is beloved by so many. As the country mourned the assassination of President John F. Kennedy, the man who had interviewed the young president on his set just months before shed a tear along with his audience. And when the *Apollo* XI rocket roared into space, the normally stoic anchor shouted, "Go, baby, go." Over the years, he did many pieces on Boston and reported about the area, most notably the 1961 documentary "Biography of a Bookie Joint," about Boston police corruption. But it's now as a summer resident of Martha's Vineyard that he sometimes makes headlines—for his charity work. One example is helping out fellow Vineyarder Art Buchwald at his last Possible Dreams auction in August 2006, which raised $730,000 for Martha's Vineyard Community Services. (A sail with Walter netted a $30,000 bid.) At the event Buchwald called Cronkite "the most trusted man in America . . . the only trusted man in America."

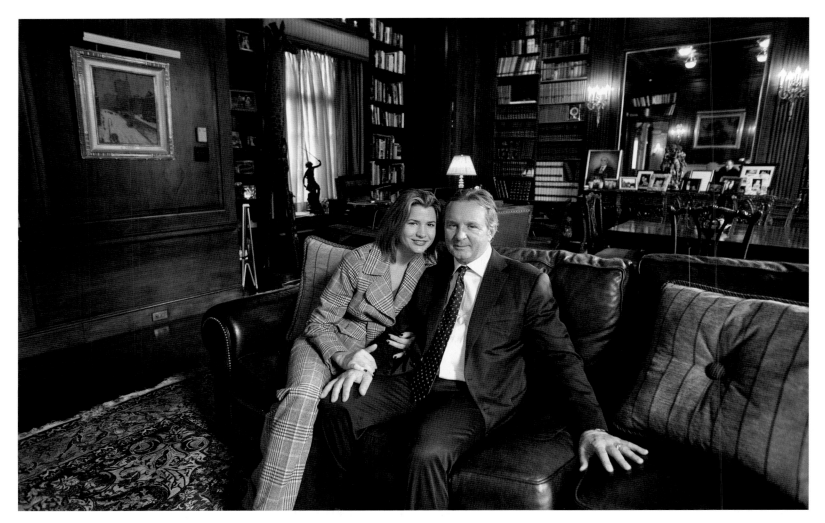

**Jay Cashman** leads the giant construction firm JM Cashman, Inc., which has worked on the largest projects in the region, including Boston's Big Dig, the MBTA's Greenbush Line, and the Boston Harbor cleanup. Jay comes by his interest in the business through both sides of his family, including John Cashman of the famous Cashman Quarry in Quincy. Jay's wife, actress and producer **Christy Scott Cashman**, is president of Saint Aire Productions. With numerous acting credits, including several starring roles, and an equally impressive list of projects on which she's worked as a producer, Christy is a key player in New England's independent film community. The couple hosts myriad events to support a host of charities, often at their Back Bay home.

**Jeanette Clough** isn't your typical hospital chief executive. Mount Auburn Hospital in Cambridge's president and CEO got her start in the medical world as a nurse, and that training and sensitivity are apparent in her management style. Not one to just sit in the office, Jeanette is often out in the hospital talking with both staff and patients. Every Christmas, Jeanette comes to the Harvard-affiliated hospital to give poinsettias to those patients who have to spend the holiday in the hospital. But the CEO pressures are still there. Jeanette oversees an $80 million campus expansion that will add a 135,000-square-foot patient-care building expected to be completed by early 2009.

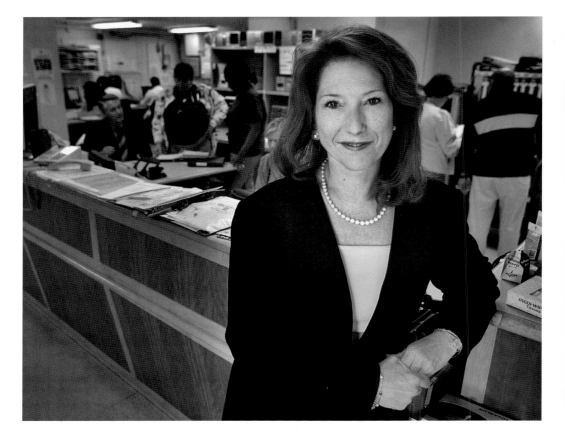

Some people are so well-known, their image so clear, that they need only one name. Yolanda is such a person. The president of Yolanda Enterprises Inc. actually has a full name, **Yolanda Cellucci.** Simply say her name and everyone in the region knows you are talking about the stunning grand doyenne of Boston's over-the-top couture. She began her business selling wigs out of her home and later opened a small store. She says that from the beginning she knew she "had to do something," so Yolanda pushed the boundaries of Boston's staid fashion scene. Soon she was attracting crowds and opened her current white (of course) building in Waltham.

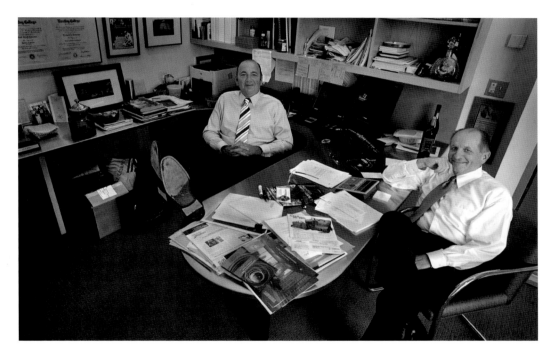

The team at Vitale, Caturano & Company blow away the myth that accountants have to be stuffy and stand apart from their community. **Richard J. Caturano** is co-founder and president of the Charlestown-based team that ranks as one of the top 40 CPA firms in the country. Cofounder and chairman **Richard D. Vitale** is a much-sought-after advisor and oft-quoted expert on financial matters. The company and both founders have also been recognized both regionally and nationally for their leadership, corporate culture, and innovative ways of doing business. But they aren't just good with numbers. This firm and its 300 employees have opened their City Square offices for community and charitable events.

Raising money for Boston's charitable groups may have started as **Marjorie O'Neill Clapprood**'s avocation, but it's now serious business for the former talk-show host and three-term state representative. Margie chairs the annual "Men Cooking for Women's Health" for the Codman Square Health Center, located in the part of Dorchester where Margie's mother—and namesake—grew up. It's also where she announced her candidacy for her 1990 campaign for lieutenant governor and her 1998 bid for the Eighth Congressional District. A former executive director of One Family Inc. and Teen Action Campaign, she started her own firm in late 2006 to do lobbying, public relations, development and strategic planning for nonprofit organizations.

An Anthony Corey tie is recognizable from across the room. But there's no mistaking **Tony Corey,** the designer, philanthropist and bon vivant, from any distance. An accomplished artist and avid horseman, Tony also is a style commentator for television and print media. A longtime supporter of Community Servings, which provides meals for those affected by cancer, HIV/AIDS, and other debilitating diseases, Tony has been commissioned to design ties for charities including breast cancer research and AIDS research. Tony frequently opens his Back Bay home for fundraising gatherings and is a regular on the charity social circuit.

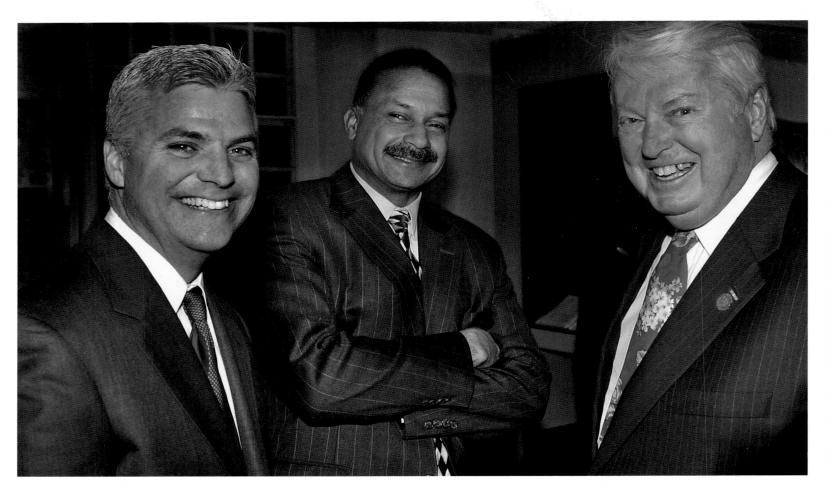

The Suffolk County District Attorney's seat has been called one of the toughest jobs in town. Current holder of the office **Daniel F. Conley** shares a moment with two previous district attorneys, **Ralph C. Martin II** and **Newman Flanagan.** A former assistant district attorney, Dan also was a Boston city councilor. After ten years as the chief prosecutor for Suffolk County, Ralph is a partner at Bingham McCutchen LLP and managing principal of Bingham Consulting Group. Newman, who has always been known for his bright and outlandish ties, is a former president of American Prosecutors Research Institute, a national professional organization.

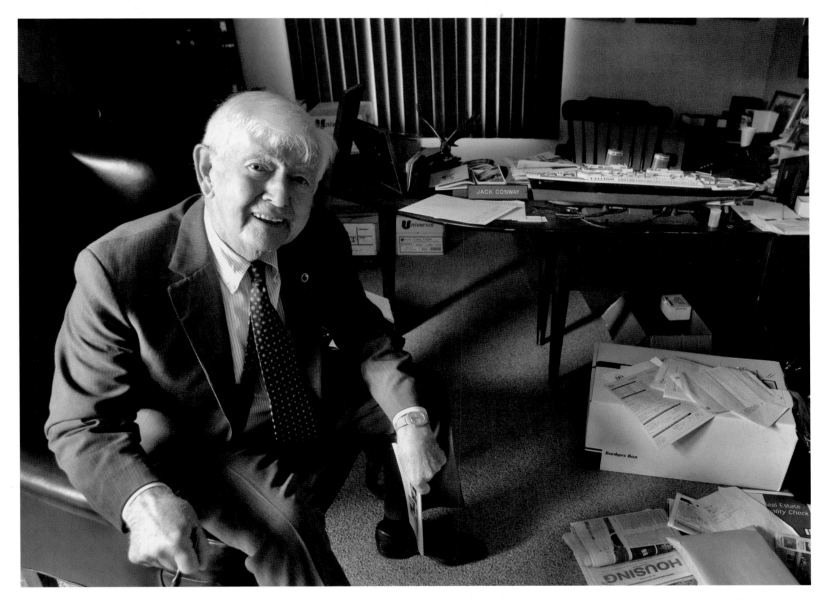

**Jack Conway** is so linked to the real estate business of Boston that his very name is a website with thousands of listings that is visited by tens of thousands of would-be buyers and renters every day. Jack left his job covering sports for the former *Boston Record American* and began a life-long real estate career. He started Jack Conway & Co., Realtor, in 1956, at a time when the region just couldn't seem to shake its economic slump. After working 12-hour days, seven days a week, Jack saw some success and turned a single office on South Street in Hingham Square into "Conway Country," covering southeastern Massachusetts and Cape Cod. With services that include residential and commercial sales and leases, mortgage financing, relocation services, appraisal services and property management, Jack Conway & Co. was ranked among the top 75 real estate companies in the United States by *REALTOR* magazine in 2004.

Many cannot recall a great Bruins game without also remembering announcer **Fred Cusick**'s voice and his famous "SCOOOORE!" whenever the B's landed one in the net. The radio veteran, who was the sports director for WEEI radio in Boston for nearly 20 years, became the Bruins TV play-by-play announcer in 1971. He retired from his Bruins duties in 1997 and from broadcasting in 2002, at the age 83. In 2006, he wrote the book *Fred Cusick: Voice of the Bruins* and has done a fair amount of touring in the region for book signings and personal appearances.

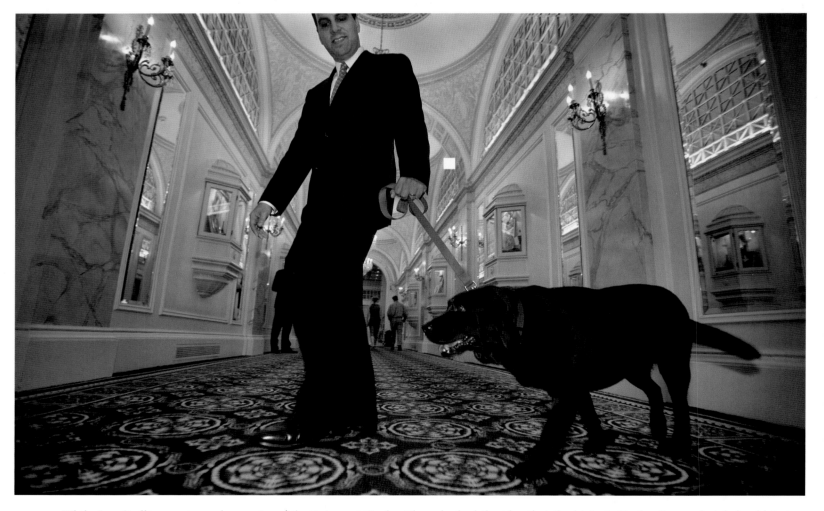

While **Jon Crellin** was general manager of the Fairmont Copley Plaza, he had the idea that the historic Copley Square hotel should go to the dogs. Actually, one dog: a black Labrador retriever named **Catie Copley**, who was originally trained to be a guide dog to assist blind people. This official canine ambassador of the hotel works several shifts a week, has a bed in the lobby, and can be taken for walks by guests. Like a hot Newbury Street stylist, Catie is often booked months in advance for her jaunts around the neighborhood. This hotel pooch may not be able to type, but she released her first book, *Catie Copley*, in May 2007.

**John** and **Diddy Cullinane** could have capitalized on his prosperity as a pioneer in the high-tech world and retired to warmer climes. But this couple has sunk their Boston-area roots even deeper; they now support a range of nonprofit organizations in Boston that promote education and cultural understanding, and help minority businesses grow in the city. Diddy is a founder of Black & White Boston, which was created in 1989 as a committee of 44 in connection with a 1990 benefit performance by Bill Cosby Catholic Charities. John founded Cullinet Software in 1968 and remains active in the industry today as chairman of the hospital software firm LiveData, Inc.

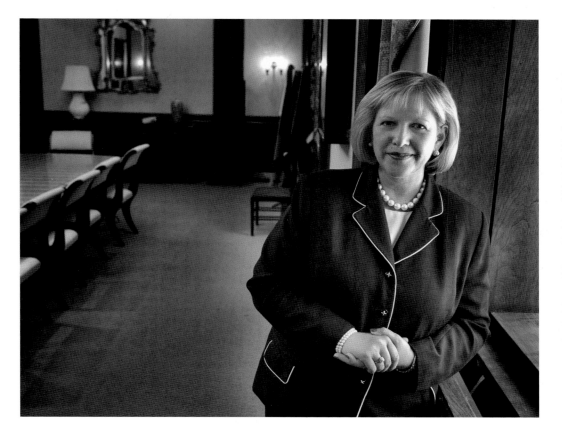

As Region President, Massachusetts–Rhode Island of Verizon Communications, **Donna C. Cupelo** has the overall responsibility for the company's service delivery, capital investment and public policy in both Massachusetts and Rhode Island. Donna began her career with New England Telephone in 1978 and has held leadership positions in Rhode Island and in central and western Massachusetts. She is active in business, civic and charitable organizations in the region including serving on the boards of the Massachusetts Business Roundtable, Boston Private Industry Council and Jobs for Massachusetts. Donna also was called upon by then Governor Mitt Romney to serve on the state's Outage Preparedness Task Force.

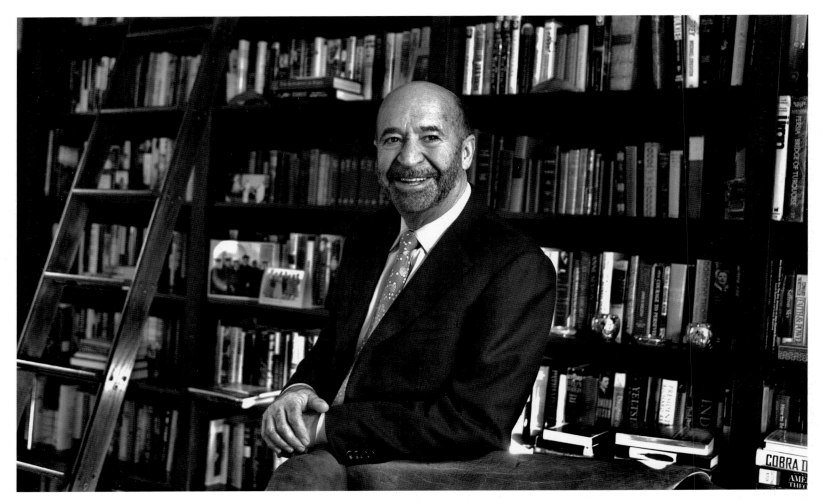

During his 12-year tenure as the chief executive of Houghton Mifflin Co. it was said of **Nader F. Darehshori** that the adroit businessman with innate leadership skills knew every business owner in Boston. While that is an exaggeration, the reverse is likely true because of Nader's involvement in so many business, charitable and civic causes. His success as a publishing executive is often credited to his love of words and reading and to his many friendships with authors. Nader's 35-year career from textbook salesman to CEO at Houghton Mifflin came to a close with a 2000 sale of the publishing house that he brokered. He then started the Natick-based education company Cambium Learning Inc., which he sold in early 2007 before looking to start yet another company.

You gotta have friends. The Langham Hotel Boston's managing director **Serge Denis** has four decades of experience as a hotelier. He was resident manager of Le Méridien Etoile in Paris and later came to the United States to open and manage the Parker Méridien in New York City and work for the company in New Orleans and Newport Beach. **David B. Waters** is executive director of Community Servings, which delivers free meals daily to 650 critically ill individuals and their families in the Boston area. Once a year, Serge and his staff turn over most of the function space in the historic Post Office Square hotel so that David and his team can hold their LifeSavor event, which allows the agency to do its work.

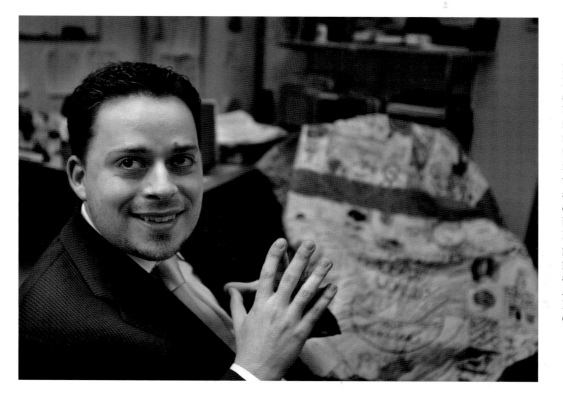

**Eric D. Dawson** has been with Peace Games since its inception as a student-run program at Harvard University. This Dorchester resident is now president of the organization that empowers students to create their own safe classrooms and communities by forming partnerships with elementary schools, families and young adult volunteers. For his dedication to the effort that was born from the ideas of Dr. Francelia Butler, who brought together the power of play with the power of peace, Eric has received several awards including Youth Service America's Fund for Social Entrepreneurs and the Echoing Green Public Service Fellowship.

The all-too-familiar political tradition of attending services for the prominent deceased brought these local politicos together in the fall of 2006 for the funeral of former Governor Edward J. King, who had over the years worked with—and against—these four men. From left, **Robert Q. Crane,** the longest-serving state treasurer (1964–1990); **Charles F. Flaherty,** former speaker of the Massachusetts House and a 15-term representative from Cambridge; **Kevin White,** a four-term (1967–1983) mayor of Boston; and **William F. Galvin,** the Massachusetts secretary of state whose first elective position was as successor to Crane representing Allston and Brighton in the Legislature.

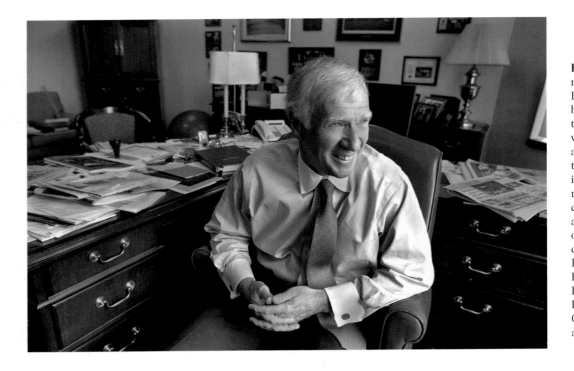

**Ronald R. Dion** has been the chairman and CEO of the real estate firm R. M. Bradley & Co. since 1997. Ron brought his focus and determination to his tenure at the helm of the privately held company which provides a broad range of real estate services throughout North America. He also is a leader in Boston's business community. He serves as trustee and chairman of John Hancock Funds; a member of the board of governors of the Boston Stock Exchange; a director of the Boston Municipal Research Bureau, the Massachusetts Business Roundtable, and the New England Council; and an Advisory Board member of the Carroll Graduate School of Management at Boston College.

When **Jim Davis** graduated from Middlebury College he thought he would pursue a career in medicine, but took the suggestion of a professor and went into sales instead. It was the right choice. In 1972, he acquired New Balance athletic shoe company, which had six employees. Five years later, **Anne Morello,** a linguistics expert for the National Security Agency in Washington, joined New Balance as its first human resources manager. In April 2007, Jim announced he was stepping down as the company's CEO but will remain its chairman. The company has expanded around the world, but Jim and Anne Davis, who married in 1983, haven't lost their focus on local charities and organizations.

In November 1620, their ancestors met the 102 pilgrims from Plymouth, England, as they disembarked from the *Mayflower* and would later teach the new inhabitants how to live off the land. The following year, the Mashpee Wampanoag Tribe would host the pilgrims for the first Thanksgiving. Today, **Glenn Marshall**, who serves as chairman of the Tribal Council, and Sachem (Chief) **Vernon Lopez**, whose traditional name is Silent Drum, oversee a thriving community that provides social services, operates camps, and preserves the tribe's vast history. In February 2007, the tribe won federal recognition as a sovereign Native American nation, capping a nearly 35-year legal battle. Since then, they have been courted to bring casino gambling to the state.

Most know **Catherine D'Amato** as an indefatigable president and CEO of the Greater Boston Food Bank who has worked on behalf of the hungry for more than 25 years. But this leader of New England's largest hunger-relief program has done something few in the region can boast of: sung the national anthem before a Red Sox home game during every season since 2004. Since Catherine took over the helm of the food bank in 1995, it has transformed into a nearly $50-million charitable organization that distributes more than 25 million pounds of food resulting in 19.5 million meals annually.

These three men standing along the Dorchester waterfront represent more than a hundred years of providing comfortable places for their neighbors to gather, comfort food and just comfort to their community. **Arthur Donovan** is owner of C.F. Donovan's in Savin Hill and until early 2007 was the owner of Patty's Pantry in Dorchester. He opened a second C.F. Donovan's in Hyde Park in 2007. **John Stenson** amiably presides over the Eire Pub in Adams Village. The Eire was known for years as a "gentlemen's prestige bar," but after a surprise 1983 visit by then-President Ronald Reagan and a later stop by then-candidate Bill Clinton, the bar has a new tagline: "Presidential Choice." Just across from the Eire is Gerard's, a restaurant run by **Gerard Adomunes.** A regular spot for many, Gerard's is a gathering point come election time.

We all know the real estate mantra: Location, location, location. But who will help you find those coveted hotspots? In Boston, one need only have **Beth Dickerson** as a guide, particularly in the Back Bay, Beacon Hill, the South End, and the waterfront. Beth started in the real estate business in 1986, running her own shop for several years before joining the residential division of R. M. Bradley & Co. where she was the company's top sales and listing broker for more than a decade. In late 2003, she started her own residential firm, Dickerson Real Estate, which became part of Gibson | Sotheby's International Reality in April 2007. A regular on the charitable social circuit, Beth supports numerous local causes.

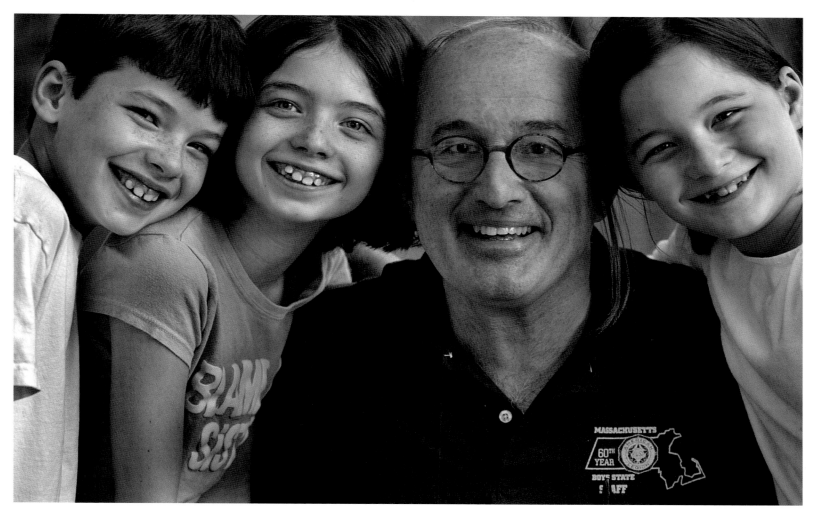

He was the president of Boston's City Council at 28 and ran for mayor of Boston four years later. **Lawrence S. DiCara** is a lawyer who practices in real estate and administrative law and public finance and is still talked about as a possible candidate for public office. He has served on numerous public and private boards and is still actively involved in a number of organizations in the city. Even with his political, legal and teaching resume, Larry stands out in one other area: He and wife, Teresa Spillane, are the parents of triplet daughters, **Sophie**, **Flora** and **Catherine**.

Carol Downs, Charlie Rose, and Katherine Mainzer, cofounders of Bella Luna Restaurant and the Milky Way Lounge and Lanes, enjoy the mural they designed to reflect the diverse musical heritage of their neighborhood, Hyde Square in Jamaica Plain, Boston's Latin Quarter. The three community organizers joined forces in the early 1990s at Citizens For Safety where they designed Boston's first Gun Buyback program and the 24-Hour Soccer Marathon for Peace to raise money for youth development programs. They launched Bella Luna (together with a fourth partner, Pierre Apollon, not pictured) in 1993 to spur the economic vitality in the square.

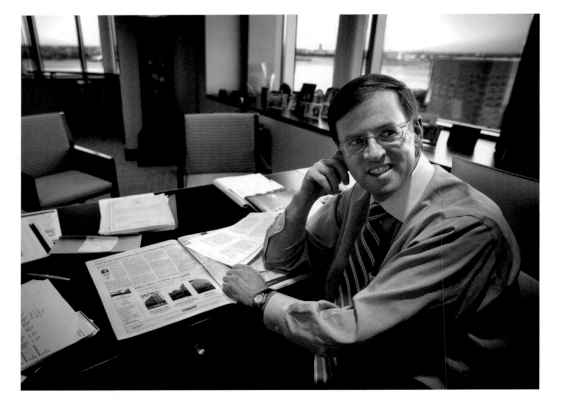

Philip J. Edmundson is the chairman and CEO of William Gallagher Associates, a firm he co-founded in 1983 that is now the largest independent insurance broker in New England. During his time at the helm of the company, Phil has overseen incredible change and growth, including tripling the employee ranks and a nearly six-fold increase in business. Phil is chairman of Affordable Care Today!!, a member of the Massachusetts Taxpayers Foundation, a member of the board of directors of the Insurance Library Association of Boston, a member of The Trustees of Reservations in Ipswich and a former member of the board of selectmen in Hingham.

Chances are you don't know **Lyndia Downie**, but for thousands in the Boston area she's one of the most important people in their lives. As president and executive director of Pine Street Inn, she manages a $30-million agency that provides temporary shelter, education and job training, and housing services for 1,300 homeless individuals and families each day. The Inn is the largest agency serving homeless people in New England, but it doesn't just concentrate on the immediate needs of its clients. It also is the largest developer of affordable housing for homeless individuals in the region.

The Driscoll Agency is a family affair. In 1960, **J. Barry Driscoll** started as a sole practitioner with a single desk in a downtown office. That bet paid off and his agency has grown into one of the leading independently owned insurance businesses in New England. Now the agency, which has provided insurance and bond solutions to hundreds of businesses and thousands of individuals, has continued into a second generation. And the family has remained active in charitable and community activities. Working at the agency today are J. Barry's children, **Jay**, a vice president; **Jane P.**, the chief financial officer; **Dennis W.**, a vice president; **Sally M.**, responsible for business development; and **Brian R. Driscoll**, the agency's president.

When **Kai Leigh Harriott**'s spine was severed by a stray bullet while she was sitting on the porch of her three-decker Dorchester house on a summer night in 2003, the then three-year-old took a place in the city's heart. But it was two years later, that Kai, who was paralyzed from the neck down, addressed a Suffolk Superior Court room and etched her place in the city's consciousness. "What you done to me was wrong," Kai told the man who shot the little girl while he was menacing two women with a .38-calibre gun. To the hushed courtroom, she added, "But I still forgive him." Those words of forgiveness uttered by a child who choked back tears long enough to whisper them echoed out across the city and made headlines around the country. Today Kai's mother, Tonya David, says her daughter is a typical elementary school student. But it's for her atypical behavior that the Robert F. Kennedy Children's Action Corp honored Kai in June 2007 with its newly christened "Embracing the Legacy" award.

**Jerry Ellis** knows that no matter how different people are, we all like "good stuff cheap." From the trademark advertising flyers to the spare decor to the free cup of coffee to never knowing just what treasure you'll find in the bins, Building #19 is as changeable and unique to New England as our weather. Although there has been debate, Jerry, who supports a number of charities, says there is no mystery to how his company and its stores got their name. "A friend, Harry Andler, rented building number nineteen in the Hingham Shipyard. I hired a high school football team to help me move everything and cleaned it and set it up." His entry into retailing in 1964 was equally happenstance. "Harry asked if I could take a look at a furniture store that had a fire. It had no roof, no elevator, but some nice furniture. We made a deal: His money against my time, until I got a job. I just never got a job."

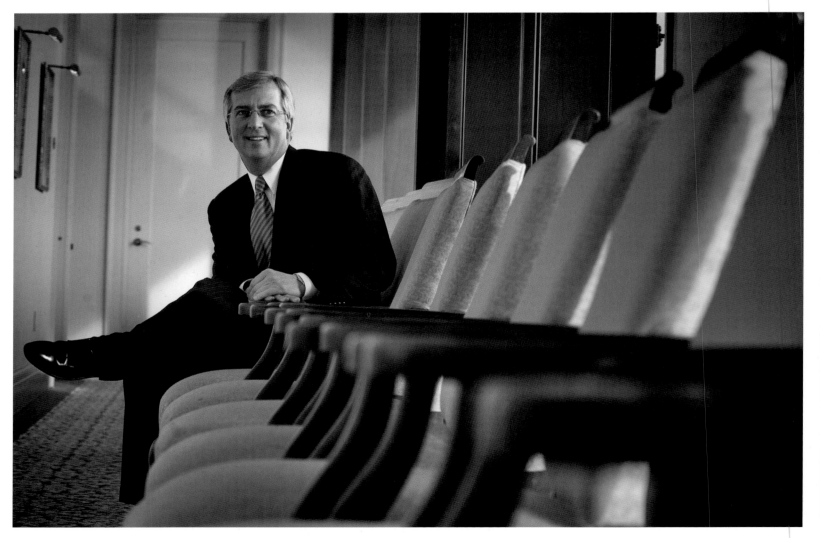

**William A. Earon** is a numbers man who has emerged as the go-to guy for many middle market and Fortune 500 Boston businesses that seek his expertise navigating treacherous financial waters. The founder and managing director of Coastal Capital Advisors LLC, Bill spent 25 years with Ernst & Young, including 13 as a partner. Bill was instrumental in assisting the film and entertainment industry with the passage of the state's tax incentive package. And in early 2007 he formed the Massachusetts Film Tax Credit Fund to monetize credits for independent producers and studios working in Massachusetts.

Shortly after acquiring the historic Parker House in 1968, **John P. Dunfey, Robert J. Dunfey Sr.,** and their family revived a tradition at the hotel that has grown into the Global Citizens Circle. Now more than 30 years old, the nonprofit, nonpartisan organization fosters constructive change in the global community through dialogue and interaction. During their time at the helm of the Parker House, the oldest continuously operating hotel in the United States, the Dunfey family updated or upgraded nearly every corner of the Tremont Street structure. Except one thing: the famed Parker House Rolls.

They are the keepers of everything from the sunflower seeds to a player's favorite piece of equipment. The Boston Red Sox clubhouse attendants quietly tend to uniforms, helmets, cleats, bats, balls and laundry, laundry, laundry. They are legendary among other employees at Fenway Park for their earnestness when it comes to the team and their private space. They even serve as a concierge service for players by handling errands or recommending places to dine or shop. They are, from left, **Jared Pinkos, Edward "Pookie" Jackson, Joe Cochran, Jack McCormack, John Coyne, Luke Ansty,** and (seated) is **Colin Barnicle.** (Missing from the photo are Visitors Clubhouse Manager Tom McLaughlin and Kenyatta Gomez, who were taking care of business elsewhere.) Always near the clubhouse is McCormack, the team's Traveling Secretary, who has the difficult task of arranging transportation and lodging for the Red Sox when they are on the road. He also lends assistance to players if any special situations should arise. Recently Jack secured housing for Daisuke Matsuzaka and his staff in spring training, and a leased home in the Brookline/Chestnut Hill area for the pitcher.

All of **Atsuko Toko Fish**'s work in Boston has been about building bridges, tearing down walls and uniting communities. She serves as a US-Japan cross-cultural communication consultant, and worked with governors Michael S. Dukakis and William F. Weld on issues ranging from tourism and trade to Asian-American relations. She is a founder and board member of HANDS, a health and development service in Japan that seeks to strengthen public health and advocacy initiatives between the Japanese government and developing countries. An overseer of the Museum of Fine Arts, she also is on the board of The Boston Foundation.

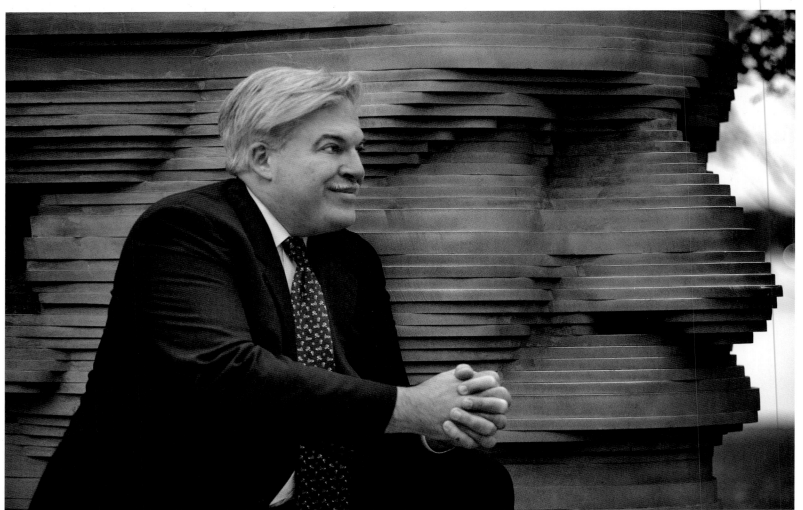

**Peter Fiedler** has made a name for himself in a city where his family name was cemented into the world's memory. Peter's portrait was taken in front of a six-foot, 10,000-pound bust of his father, the late famed conductor of the Boston Pops Orchestra, Arthur Fiedler. Located on the Esplanade near the Hatch Memorial Shell that the maestro made famous, the memorial to the Boston-bred Fiedler was unveiled in 1984, nearly five years after his death. Peter is vice president for administrative services at Boston University, having previously served in a variety of capacities at the university. Being at BU holds a special significance for Peter because his father taught at the College of Fine Arts and was given an honorary degree by the university.

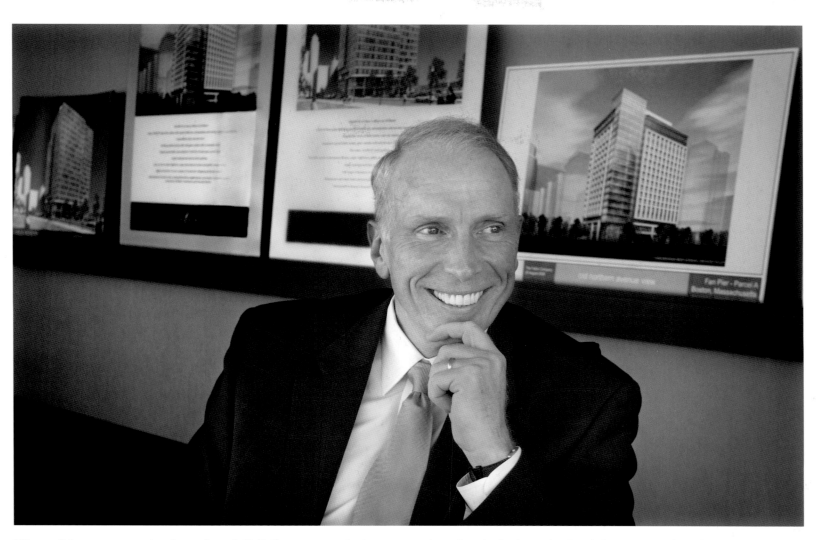

When talking to veteran developer **Joseph F. Fallon,** you get the impression that when he looks at the South Boston waterfront he can actually see what the still-open parcels will look like when all of the planned projects are complete. A quiet and humble man in a business marked by loud egos and grandiose personalities, the veteran Boston builder has taken on one of the city's biggest conundrums: the development of Fan Pier. In early 2007, Joe was moving forward on securing tenants for his office space, had begun to market the condos planned for the Seaport District tower that promised striking views of Boston Harbor, and was gathering support from the city and the community to get the project underway.

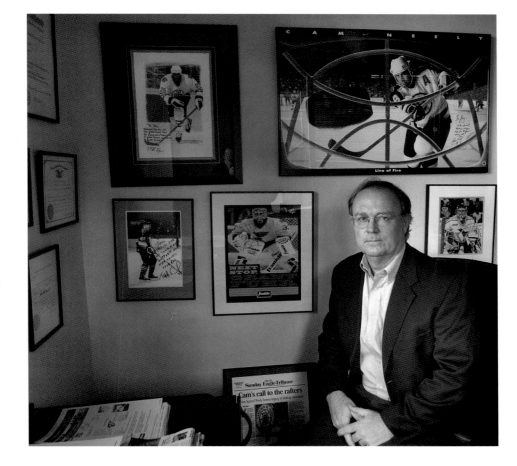

It was in 1991, after five years of practice as a corporate attorney, that **Jay Fee** started concentrating on sports law. A short time later he joined the Boston sports agency Woolf Associates, where he was vice president and director of the hockey division. Now, as president of Blue Sky Sports & Entertainment, a firm he founded, Jay is enjoying a successful run. His first client was former Boston Bruins star and NHL Hall of Fame inductee Cam Neely. He has expanded his client base across the NHL and to other areas and has brokered endorsement and sponsorship agreements for pro athletes of all stripes.

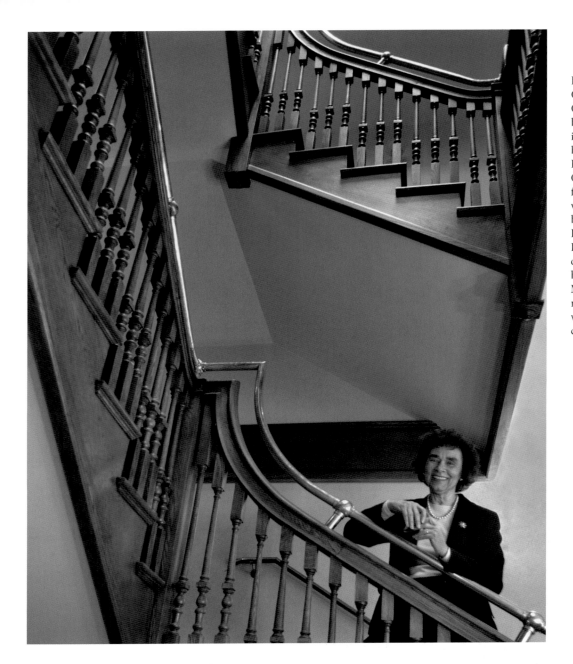

**Ruth Ellen Fitch,** the president and CEO of Dimock Community Health Center, grew up in Roxbury—just blocks away from the community institution that was founded in 1862 by women physicians as the New England Hospital for Women and Children. After working as a lawyer for 21 years at Palmer & Dodge, where in 1991 she was the first black female partner at a large Boston law firm, Ruth Ellen came to Dimock in 2004. She is a former director of METCO who once taught black literature at University of Massachusetts Boston. She's won numerous awards and has worked with a host of community, civic and charitable organizations.

**Ed Forry** is publisher, and his son **Bill Forry** managing editor of Boston Neighborhood News Inc., a Dorchester-based, family-owned newspaper and internet company. Formed in 1983 by the elder Forry and his late wife, Mary Casey Forry, the firm publishes two weeklies, *Dorchester Reporter* and *Mattapan Reporter;* two ethnic monthlies, *Boston Irish Reporter* and *Boston Haitian Reporter;* and websites for all four. Both father and son are graduates of BC High School and Boston College and lifelong Dorchester residents. Ed is co-founder with legendary Boston ad man Steve Cosmopoulos of "OFD—Originally From Dorchester," a loose confederation of persons born and brought up in that Boston neighborhood.

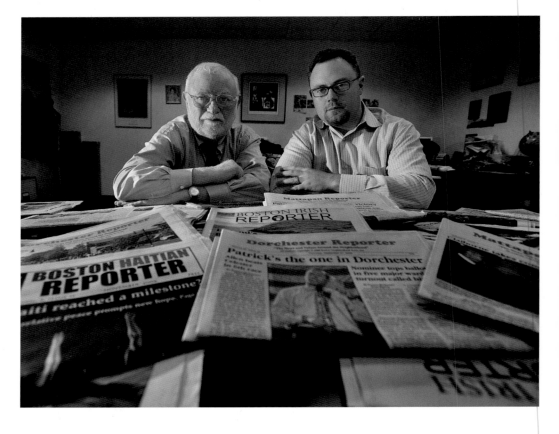

It was while reading an article during her first year of graduate school that **Shirley Fan** realized she wanted to—had to—do more for women who were being victimized. A Chinese native from Hong Kong, Shirley came to Massachusetts to pursue a degree in social work after leaving Digital Equipment Corp. The executive director of the Asian Task Force Against Violence since 2000, she got involved with domestic violence victim services work while she was a student. She has served on numerous boards and commissions in the region. In fall 2006, Shirley and several other women founded the Asian Women Connection Inc., a nonprofit network.

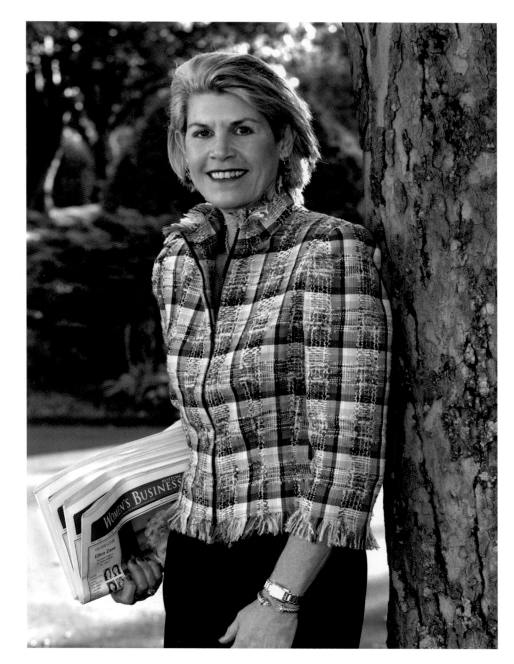

The founder and publisher of *Boston Women's Business,* **Vicki Donlan** doesn't just cover the issues that most women face in the business world, she lives them. The first executive director of the Commonwealth Institute, Vicki was the first executive director of the South Shore Women's Business Network and founder of the Alliance of Women's Professional Organizations. Having spent more than 12 years of her early career in the newspaper business, Vicki launched *Boston Women's Business* to give "ego to women and change the face of business news." She sold her publication to the *Boston Herald* in late 2004, but continues to serve as its publisher. Active in civic affairs, Vicki has a book, *Her Turn: Why It's time for Women to Lead in America,* due out in fall 2007.

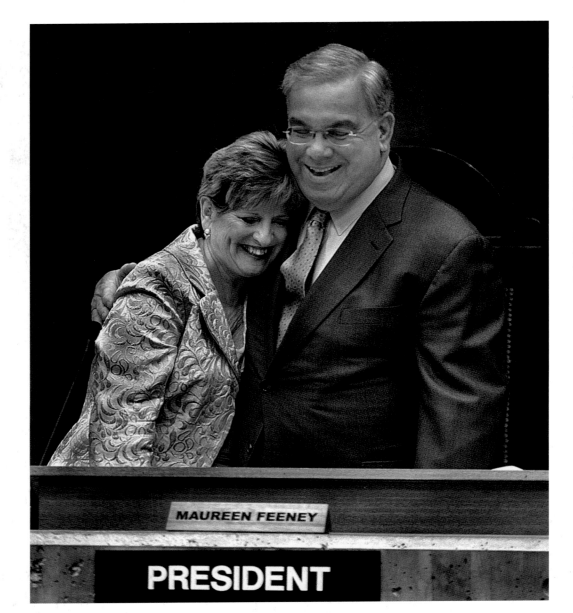

You may see just one person being congratulated here by Mayor **Thomas M. Menino.** But when **Maureen E. Feeney** was elected president of Boston's City Council in 2007 it was because of the thousands she has helped in her 13 years representing Dorchester, and the many more who have supported her in return. As just the first woman to win the council's presidency since Louisa Day Hicks ruled the chamber in 1976, Maureen has expanded her concerns to the issues that affect the city as a whole including public safety and Boston's public schools.

MAUREEN FEENEY

PRESIDENT

As executive director and secretary of Boston's Redevelopment Authority, **Harry F. Collings** is responsible for making sure that, when it comes to the big projects in the city, all the i's are dotted and all the t's are crossed. But that's only a sliver of what Harry really does. He's the authority's liaison to the arts, cultural and civic projects built in the city. Among the projects Harry has worked on are the new Institute of Contemporary Art, the restoration of the Opera House, and the Fenway Community Health Center, which is slated to open in 2009. And there's his community involvement and volunteer work, including the AIDS Action Committee and the Gay and Lesbian Political Caucus.

Fashion designer **Denise Hajjar** knows women will go to any lengths to look good. So this Boston-bred, Boston-based creator of women's clothing has dedicated herself to making sure women in this city don't have to travel to the traditional fashion centers to look their best. After nearly 25 years in the business, operating out of a converted factory in the South End, Denise opened a boutique in the lobby of the Fairmont Copley Plaza hotel in July 2006. Her charity work includes the American Heart Association's Go Red for Women and the St. Jude's Children's Research Hospital.

Located in a former inn, the Quincy offices of the South Shore Chamber of Commerce are almost as enviable as the membership roster of and growth shown by the organization, which is the second largest Chamber in New England. President and CEO **Peter Forman** is joined by his immediate predecessor **Ronald E. Zooleck,** who held the top post at the chamber for 26 years. Peter is a former Plymouth County sheriff and state representative for the Plymouth area. Ron spent 42 years leading Chambers of Commerce in New England—including his time with the South Shore Chamber, which is the largest in eastern Massachusetts—before joining Sovereign Bank in early 2005 as its executive director for business development.

Century Bank isn't another large financial institution claiming to be a family business. It is the largest family-controlled bank in New England. With more than 400 employees and 23 branches, Century also ranks as the fourth largest independent bank in the region. Founded in 1969 by **Marshall M. Sloane**, who serves as chairman, the bank has assets of more than $1.7 billion. His children continue to operate the bank. **Jonathan G. Sloane** and **Barry R. Sloane**, co-CEOs, and their sister, vice president **Linda Sloane Kay**, remain true to their father's commitment to the communities they serve. The Sloanes are involved in numerous civic and charitable endeavors.

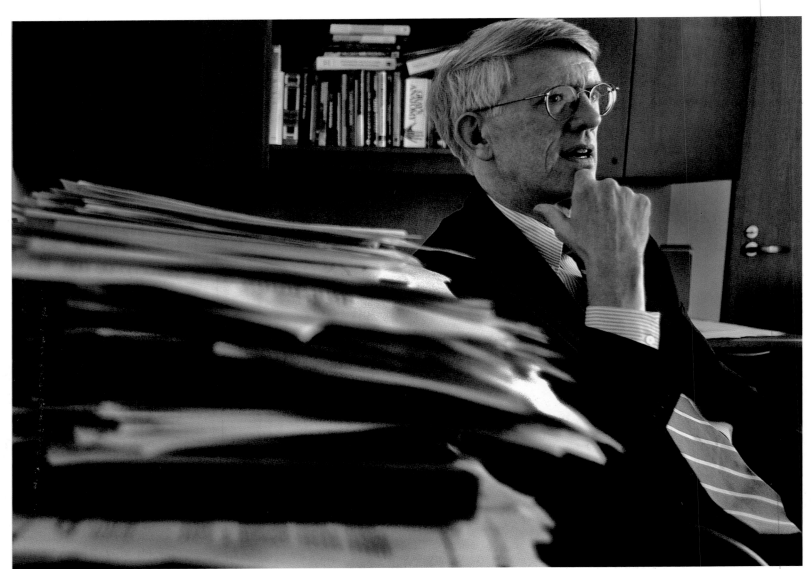

Chances are you've crossed paths with **Thomas P. Glynn III**, or one of the many agencies or enterprises with which he has worked. As chief operating officer of Partners HealthCare's network of hospitals and physicians, Tom oversees the non-medical side of the organization, including finance, human resources and real estate. Before joining Partners in 1996, Tom was deputy secretary of the US Department of Labor during the Clinton Administration, a senior vice president at Brown University and general manager of the MBTA, and he worked for the state's Department of Public Welfare. Tom is chair of the board of overseers of the Heller School at Brandeis University, where he received his doctorate.

Whenever someone commits an act of violence big enough to make the national headlines, the world turns to these three Northeastern University professors looking for answers. Former dean and Lipman Family Professor of Criminal Justice **James Alan Fox** has published 16 books on subjects including multiple murder, juvenile crime, and school and workplace violence. **Jack Levin** is the Irving and Betty Brudnick Professor of Sociology and Criminology and director of the Brudnick Center on Conflict and Violence at Northeastern University, where he teaches courses in prejudice and violence. **Edith E. Flynn** is a professor emeritus at Northeastern, and remains a much sought-after speaker on terrorism.

**Peter Gammons** may have a big smile on his face when he straps on a guitar and takes to the stage with Boston rocker **Kay Hanley**, but for this premier commentator on America's pastime, making music is serious business. The baseball guru, whose sharp coverage and breadth of knowledge have earned him a spot in the Baseball Hall of Fame in Cooperstown, suffered a life-threatening aneurysm in June 2006. Through a speedy recuperation, he was back before the end of the season and was able to return to the winter 2007 edition of Hot Stove, Cool Music, the twice-annual charity concerts he has organized with Red Sox general manager Theo Epstein.

For the Driscolls, all roads lead back to Melrose, where this portrait was taken at the historic Beebe Estate. **John S. Driscoll,** former editor of *The Boston Globe,* and his brother, **David P. Driscoll,** the state's commissioner of education, are the youngest of ten children. Jack started at the *Globe* at 16 as a Melrose correspondent and worked his way up to become the newspaper's editor, serving until 1993 when he was named vice president. The state's highest ranking education official since 1998, Dave retired on August 31, 2007. He previously served as the superintendent of schools for Melrose.

**Doris Kearns Goodwin** already had two of the largest prizes possible for her *New York Times* bestseller, *Team of Rivals: The Political Genius of Abraham Lincoln,* when she faced up to a far greater personal challenge—crossing the plate with a ceremonial pitch. An avid baseball fan, Doris was asked to make the first pitch at the Oldtime Baseball Game, a charity event in Cambridge that raised money for C-2 Mission, an organization that assists families affected by cerebral palsy and cystic fibrosis. Doris is the author of the Pulitzer Prize–winning bestseller *No Ordinary Time: Franklin and Eleanor Roosevelt: The Home Front in World War II;* as well as *The Fitzgeralds and the Kennedys: An American Saga. Team of Rivals* is getting made as a movie by Oscar-winning director Steven Spielberg, with a score by John Williams and starring Liam Neeson as Lincoln.

**Barbara W. Grossman** and **Susan Lewis Solomont** have so much in common, you might think they've known each other all their lives. These friends met through their husbands, Steven and Alan, who work as Democratic activists and fundraisers. Barbara is an associate professor and chairwoman of the Drama and Dance Department at Tufts University, where she received her doctorate in drama. Susan is a senior fellow at The Philanthropic Initiative, a nonprofit consulting firm that works with individuals and organizations. Before joining TPI, Susan worked for 18 years at WGBH-TV and radio as director of corporate development. Barbara and Susan have worked together in support of several area charities including The Second Step. They are both dog lovers: Barbara is with her English springer spaniel, Charlie, and Susan is holding her cockapoo, Stella Blu.

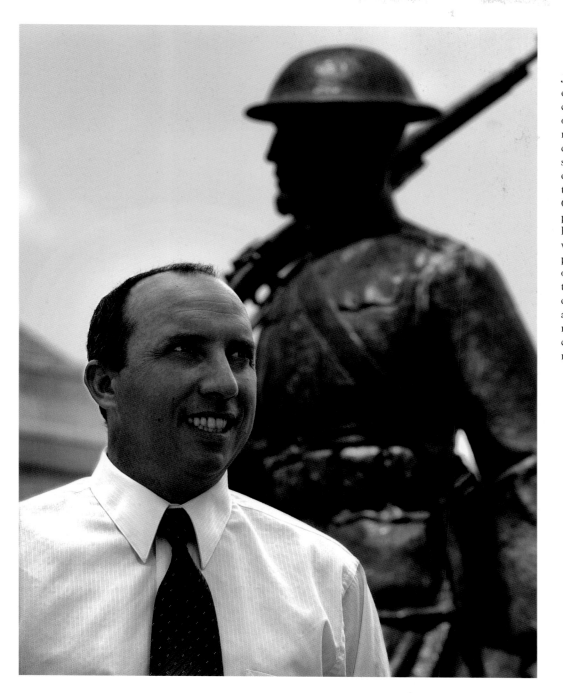

**John S. Gonsalves** says that the events of September 11, 2001, changed his life as they did for many of us. But when he was watching the news about a wounded soldier one day, this licensed construction supervisor with two decades experience in the field decided to do something more. He founded Homes for Our Troops, a Taunton-based non-profit group that builds or adapts homes to meet the needs of severely wounded service members. And they provide all the services at no cost. In only a couple of years, the organization has completed two dozen projects in 15 states. In March 2007, just a few days before their first big fundraising event, John got a $3 million check in the mail from an anonymous donor.

If you get the support of one Glovsky brother, you get the support of all three. **Richard D. Glovsky,** with the firm Prince, Lobel, Glovsky & Tye, is a nationally recognized trial lawyer and employment law attorney. A veteran of the financial industry, **Charles S. Glovsky** is director of Small Cap strategies and a senior portfolio manager for Independence Investments. **Robert J. Glovsky** is the president of Mintz Levin Financial Advisors, which was founded in October 1998 to provide wealth management and investment advisory services to individuals and families. All three are actively involved in the community. In 2002, the Glovsky brothers received the prestigious Community Service Award from the American Jewish Committee.

When the doors of Harrington House opened in 2005, **Jack Harrington** literally gave something back to the neighborhood where he grew up. Named for Harrington's parents, John and Patsy, the house is the former Mission Hill High School convent that has been transformed into a 12-bed group home for at-risk children ages 8 to 13 and their families and is run by the Home for Little Wanderers. As remarkable as the work that quietly goes on in the house is the extraordinary effort by so many to make it happen. Harrington, a member of the Home's board of directors, and **John Fitzgerald,** who is Harrington's co-president of Atlantic Associates, a Boston-based IT placement agency, were joined in the effort by Putnam Investments, which bought the convent, and hundreds of volunteers who performed an "extreme makeover" to rehabilitate the beautiful old building. "The previous house was rented and beyond repair," said John Fitzgerald about the Spring Park Place building that was unsuitable for children. "This spot was one that a lot of developers wanted to get their hands on, it's such a great property. And once the community saw what the project was, it was all able to fall into place."

That a place like Charles Street Supply Co. still exists might be a surprise, but it's a joy to walk into the hardware store that has served Beacon Hill since 1948. **Dick Gurnon** was a salesman when he called on a man who had just opened a tiny hardware store in a basement on Charles Street. They became partners in 1952. Over the years, the store has moved, been reincarnated (once after a fire), and expanded at its current location at 54 Charles Street. It now boasts an inventory of more than 24,000 items. As Dick's son **Jack**, the current owner, tells it, they've had a cast of characters helping out over the years, but Boston's oldest hardware store keeps on ticking.

As Mitt Romney's administration was in its last weeks at the State House, something special happened. All the living inhabitants of the corner office, and one who soon would report for work there, gathered in the shadow of the golden dome to have their photograph taken. They came simply because Bill Brett asked them if they would. **William F. Weld**, far left, served from January 1991 to July 2007. **Deval Patrick** was still in the planning stages of his administration, which would take office on January 4, 2007. **Michael S. Dukakis** served from January 1975 to January 1979 and from January 1983 to January 1991. **Jane M. Swift** was in office from April 2001 to January 2003. **Paul Cellucci** was governor from July 1997 to April 2001. And then-Governor **Mitt Romney** served from January 2003 until January 2007.

As president & CEO of Garber | FCm Travel Solutions, **Roz Garber** has helped people get around the world, but it's around the community that Roz has made her greatest mark. In addition to numerous travel industry posts, Roz runs one of the five largest woman-led businesses in the state. She has been a leader in Boston's Jewish community and has involved her company in a variety of charitable organizations in both large and small ways. Figuring it wasn't enough to throw corporate support behind the Home for Little Wanderers, Roz and her employees turned their holiday Secret Santa into a gift drive for the Home.

**Donna Latson Gittens,** founder and principal of causemedia, inc., has been called a rainmaker extraordinaire and is considered one of the nation's leading authorities on cause-related marketing. Through her philosophy of "doing well by doing good," Donna and her company have carved out a niche among the global advertising agencies in Boston by dedicating causemedia's efforts to working with socially conscious corporations and not-for-profit organizations. A Boston native and resident, Donna launched her agency in 1997 after a 20-year career as a corporate executive at Boston's ABC affiliate, WCVB-TV, where she was an innovator in community programming.

**Seth Greenberg** once ruled Boston's hipster night-life. He owned and ran the Paradise, the Commonwealth Avenue club that launched numerous musical and comedy acts. Later he created and owned Aria, a Theatre District late-night hotspot. After opening the chic New York event space Capitale in the Bowery, demand grew so much that Seth and his partners opened a second uptown location. Like the clientele he served, Seth has matured and reconnected with Boston. The managing director of *Boston Common* magazine, Seth announced in early 2007 that he's looking to open a new restaurant in Boston.

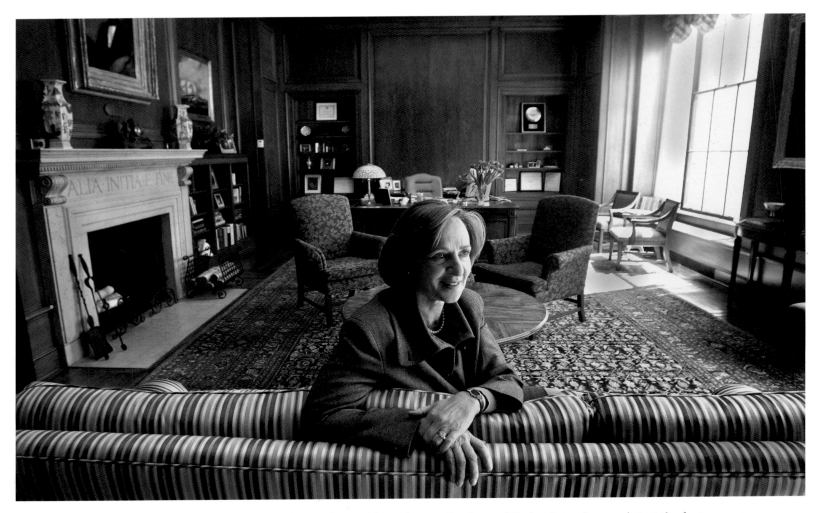

When **Dr. Susan Hockfield** was named the sixteenth president at Massachusetts Institute of Technology, she wasn't just the first woman to hold the position. A neuroscientist whose research has focused on the development of the brain, Susan is the first life scientist to lead the university. She told a *Boston Globe* columnist that she hoped her presence would "give confidence to girls and young women that there are opportunities that will be open to them that they can't imagine right now." And it's something she lives. Susan, who continues to hold a faculty appointment as a professor of neuroscience, has focused her research on the development of the brain and on glioma, a deadly form of brain cancer.

**Philip C. Haughey** runs The Haughey Company, Inc., a real estate investment, development, and management firm in Boston, with sons, **Christopher M.** and **Philip C. Haughey Jr.** The family has championed numerous causes including the American Ireland Fund, the Boston Irish Famine Memorial, the Catholic Foundation of the Archdiocese of Boston, and Caritas St. Elizabeth's Medical Center. But the Haughey name will be forever linked to Harvard's Soldiers Field and other sports venues on the university's campus. While at Harvard, Phil Haughey played three varsity sports (baseball, basketball, and football) before graduating in 1957 and he is now president of the Harvard Club.

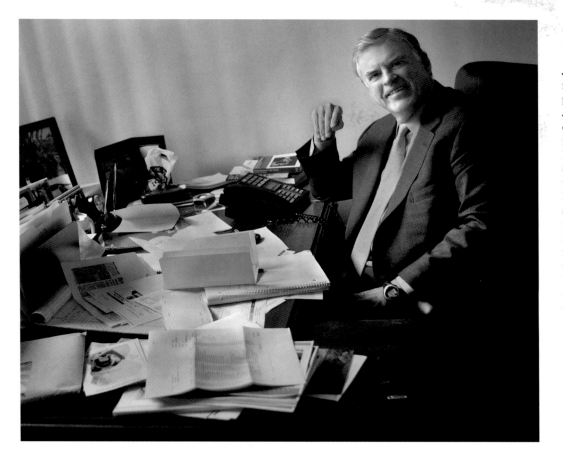

**John L. Hall II** is a familiar name to many, but his building projects are part of the daily lives of many more. John's a co-founder of the real estate development, management and investment company Hall Properties, Inc., and a general partner of the Suffolk Downs thoroughbred race-track in East Boston and the Charles Hotel in Cambridge. John developed and is managing partner of several medical office buildings in New England. A Boston University alumnus, John has served as a trustee of Children's Hospital, corporator of Boston Children's Museum, trustee of Proctor Academy and former chairman of the Board of the Park School. He is a director of the Brookline Saving Bank.

There are a couple of recurring themes for the Roys: family and the environment. Sisters **Ellen Roy Herzfelder** and **Jane Roy**, along with their brothers, Peter and Stephen, have held to a path that was carved out by their parents, the late Mary Louise and John Reime Roy. Ellen was the state secretary of environmental affairs during the Romney administration, who, despite being wooed to run for statewide office, stepped down in 2005 to spend more time with her family. Jane, who is active with the Boys and Girls Club of Boston, has chaired the Party in the Park to raise money for the Emerald Necklace Conservancy, which preserves Frederick Law Olmsted's park system. And the Roys are known for opening their family's Back Bay home for charity events of all stripes.

The Boston Red Sox World Series Championship was a long time coming but no less rewarding for these Fenway legends. At a benefit for the North End Community Health Center on May 17, 2005, at the Boston Harbor Hotel, Red Sox centerfielder Dom DiMaggio awarded John W. Henry, principal owner of the Boston Red Sox with the second annual Dom DiMaggio Public Service Award. Henry returned the favor and presented DiMaggio and Hall of Fame second baseman Bobby Doerr with team championship rings. Joining his former team-mates for the occasion was shortstop–third baseman Johnny Pesky, who got his ring on April 11, 2005. As part of the opening, day cere-monies Pesky, with the help of Carl Yastzremski, raised the 2004 World Series Championship banner up the Fenway Park center field flagpole. The Boys of Summer, who couldn't be prouder to flash their long-awaited bling are, from left: **John Henry, Bobby Doerr, Johnny Pesky** and **Dom DiMaggio.**

When **Ralph Hodgdon** and **Paul McMahon** were married by Justice of the Peace **Michael Shaps** at the Public Garden on May 29, 2004, anyone walking by might have thought it was just another beautiful wedding on a lovely day. But for the couple, who had been together for 49 years when same-sex marriages became legal in Massachusetts, it was the affirmation of their relation-ship. They were joined that day by longtime friends **Barbara Allan,** who served as best matron, and **Marc Grossman,** the best man. "We'd thought about waiting until our 50th and having something spectacular," Hodgdon told a reporter from *The Boston Globe.* "But then we thought, why push fate? People our age are dropping off."

**John T. Hailer** is president of the Boston-based IXIS Asset Management Advisors Group, which connects financial advisors and their clients to a broad line-up of specialized money managers and is part of one of the world's largest global investment firms. Before joining IXIS in 1998, John was a senior vice president with Fidelity Investments Institutional Services Company and a senior vice president for Putnam Investments. Even with all of his success in the local financial community, it is through his civic service that many in Boston know John. He is chairman of the board of the Home for Little Wanderers and is active in the United Way of Massachusetts Bay.

They may look like a glamorous Hollywood couple, but **Charles C. Hajjar** and his wife, **Anne Tamer Hajjar,** do their work far from the flashy headlines and glitzy parties. They met at church and spend much of their time out on the town raising money for charitable causes, particularly St. Jude Children's Research Hospital. They both grew up in the area: She graduated from Boston Latin; he's a Boston College High School alumnus. He started in the real estate business at age 21, and their holdings now include two hotels in Boston, including the boutique inn The Charlesmark Hotel. She still works with her husband on special projects, but her highest priority is their four children.

**Sister Bridget Haase** sees the evidence of faith daily in her work at The Boston Home, a residence for disabled adults with advanced multiple sclerosis and other progressive neurological diseases. Then, in 2005, her own faith was tested with a breast cancer diagnosis. After a series of setbacks, Sister Bridget, who is director of the Home's Spirituality and Wellness Program, said she then asked others to pray for her. "Everybody," she told a writer for *The Boston Globe.* "I asked them to pray with me. I continued to pray, very much so, on my own. But there comes a time when you know you need others to lift that prayer," said the Ursuline nun who lives in a convent in Dedham, where this photograph was taken.

As a trial lawyer for K & L | Gates, **Thomas F. Holt Jr.** advises some of the most powerful people in the country. But as a private citizen, Tom has provided much needed support and time to numerous charities in the region. He serves on his firm's management committee and coordinates intellectual-property and technology litigation. He is a member of the Boston College Law School's board of fellows, serves on the board of trustees of the Dana-Farber Cancer Institute and the Dana-Farber's Science Committee, and is on the board of directors for the New England Council.

Their family's late patriarch, Thomas Geraghty, emigrated from County Galway, Ireland, to the Boston area and set up a small construction firm with his brother Peter. After Thomas's death more than 20 years ago, **Margaret Geraghty,** shown here with her son's dog Honey, took over Geraghty Associates, which had grown beyond rebuilding single houses to include managing properties. Peg has since been joined in running the residential property management firm by her children **Thomas Jr., Anne, and John Geraghty.** As a family, the Geraghtys support a number of causes including the Boston Irish Famine Memorial project.

The Hunt family are a loyal bunch. **James W. Hunt III,** the chief of environmental and energy services for the City of Boston, was described by one of his City Hall colleagues as a "True-blue Mr. Green." He's Mayor Thomas M. Menino's lead advisor on environmental and energy policy and oversees several city agencies including the Inspectional Services Department, the Environment Department, Parks Planning, and Boston's recycling program. His father, **James W. Hunt Jr.,** has been president and CEO of the Massachusetts League of Community Health Centers since 1979. This lifelong resident of Dorchester is a community activist at heart, but he's played multiple roles in the public health and policy arena over the years.

If you want to know about the many accomplishments of **F. Gorham Brigham Jr.**, the dean of Boston's number-crunchers, seated at right, you'll have to ask someone like **Mark B. Kerwin**, president of the Treasurers' Club of Boston, which was founded by Brigham. Even Mark, who is the chief financial officer of the Museum of Fine Arts Boston, is reluctant to divulge the details of his mentor's life because Gorham is that private. Founder of the Treasurers' Club, Brigham can trace his ancestors to the *Mayflower*. This Senior Vice President for Commercial Lending at Citizens Bank of Massachusetts also is a tireless community activist. While his contributions to the Boston area could fill a book, he considers his most outstanding accomplishment to be the 1967 co-founding of the Carroll School in Lincoln for children with dyslexia.

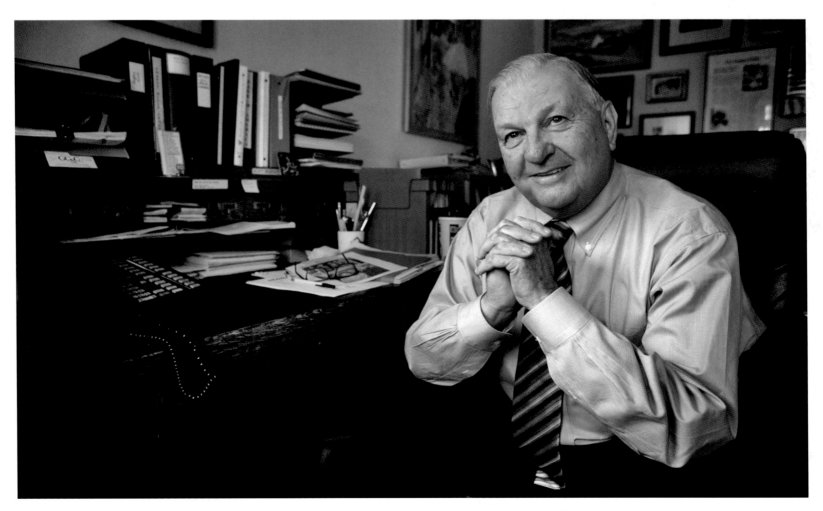

When he's not busy warming thousands of homes and buildings, this former president of Hughes Oil Co. is active in many charities and as a volunteer. **Richard T. Horan** is a trustee and activist at Boston College, where under the leadership of former president Rev. J. Donald Monan, SJ, Dick and several others are credited with rejuvenating the alumni base and working to expand the school's campus. Dick's also a trustee of The Catholic Foundation, Forest Hills Cemetery, Notre Dame Education Center, and Caritas Carney Hospital. All of his community work and the parenting of seven children with his wife, Joan, is Dick's way of "living in service to others."

That they have defied the odds and made it this far as a nonprofit is not lost on the cofounders of Artists for Humanity. **Rob Gibbs, Susan Rodgerson,** and **Jason Talbot** are among those who came together in 1991 to form the nonprofit after-school program for teenagers who work with mentors to make and sell art. Rob and Jason were students when the program was started and they've continued their involvement. Susan, a painter who serves as executive director and artistic director, admits things didn't always look like they'd turn out so well. But Artists for Humanity hasn't just survived, it has thrived. In 2006, the group opened its new home in South Boston, a "green" building called the EpiCenter.

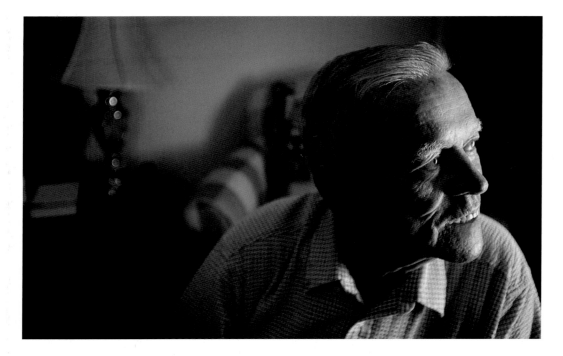

He's participated in nearly fifty St. Patrick's Day parades in South Boston, many as the chief organizer. But **John "Wacko" Hurley** has another distinction: a 9-to-0 ruling by the US Supreme Court over the right to ban an Irish-American gay and lesbian group from marching in the annual parade. Wacko, who earned his nickname from the wacky pranks he and friends in Southie used to pull, is a retired MBTA employee and Korean War veteran. As for the ban on the gay marchers, Wacko insists it was a matter of free speech, stating in 2003: "The Supreme Court said 9-0 that if we don't like the message it's our prerogative, and that should have been the end of it."

A former Fortune 500 business strategist who served as an aide to the Clinton administration, **Lynn Margherio** was visiting with her nieces and nephews in Detroit when she noticed how many outgrown clothes and toys they owned—most in good condition. She knew there were others who might make good use out of such items, but it was often difficult for families to get their things to the families that were most in need. In 2002, she founded the Quincy-based Cradles to Crayons. Just five years later, more than 75,000 local children-in-need have received packages from the nonprofit group.

When Governor Mitt Romney appointed **Pierre Imbert** as the director of the Massachusetts Office of Refugees and Immigrants in 2005, the state's newest residents couldn't have found a more committed advocate. A trilingual former executive director of the Haitian Multi-Service Center in Dorchester, Pierre was awarded the Catholic Charities Medal in 1997. As director of the state agency, Pierre oversees 20 employees and a $15 million budget. He serves on the boards of Fontbonne Academy, Caritas Carney Hospital, Project Bread, and SEED, a community economic development loan fund from Haiti.

As the CEO of the Jesuit Catholic college preparatory Boston College High School, **William J. Kemeza**'s official title is "The Director of the Work." On a daily basis, Bill goes by a far more familiar title of President and as such is responsible for the school's mission and long-range planning. He is the first non-Jesuit to hold the position since the school was founded in 1863. Bill's been at BC High for more than 20 years, serving as teacher, vice principal, principal, and, since 2002, president. His wife, Rev. Dr. Maureen Dallison Kemeza, is an Episcopal priest at Emmanuel Church on Newbury Street.

When Team Hoyt—father Dick who pushes his quadriplegic son Rick in a specially made wheelchair—is on the course of the Boston Marathon, you know they are approaching by the roaring cheers. Now a favorite with the runners and throngs of fans who line the 26.2 miles from Hopkinton to Boston, for **Dick** and **Rick Hoyt** it has been an uphill struggle. "It's been a story of exclusion ever since he was born [in 1962]," Dick says on the family's website. "The doctors told us we should just put him away—he'd be a vegetable all his life, that sort of thing. I would like them to be able to see Rick now." On Patriots' Day 2007, they missed—for only the second time—running the Boston Marathon because Rick was recovering from hip surgery. The many miles of training—and the subsequent successes including finishing several triathlons—came for the Hoyts after Rick asked his dad, with the aid of a computer, if they could enter a race to raise money for a high school classmate. That experience changed the lives of both father and son forever, according to a *Sports Illustrated* columnist: "Dad," Rick typed, "when we were running it felt like I wasn't disabled anymore."

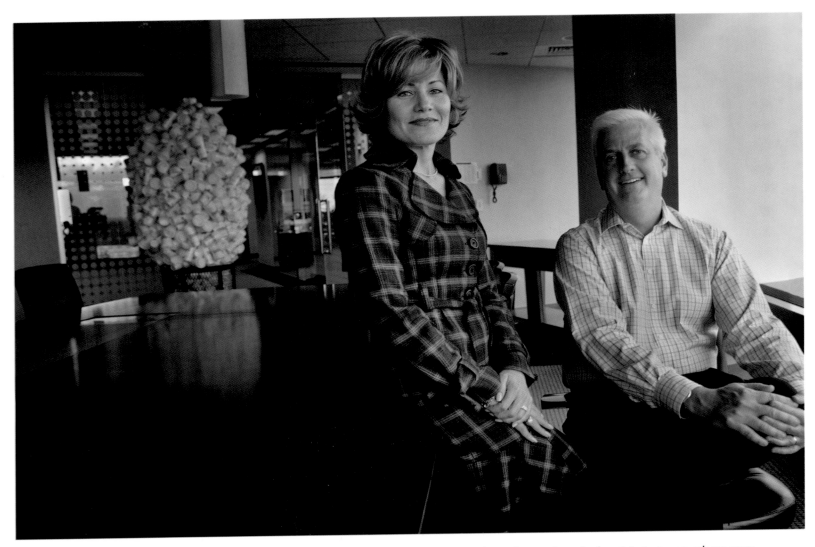

**Karen Kaplan** and **Mike Sheehan** oversee the daily operations of Hill | Holliday, the stalwart Boston-based advertising agency, whose very name is as well-known as the companies it represents. Mike is the first non-founder to hold the title of CEO at Hill | Holliday. A former executive creative director, Mike and his work have won nearly every industry creative award. Karen is president of the agency's Boston headquarters. She joined Hill | Holliday in 1982 as a receptionist and now ranks among the city's most powerful women. She serves on the board of the Massachusetts Society for the Prevention of Cruelty to Children and the United Way of Massachusetts Bay. Karen also serves on the advisory council of Urban Improv and the board of mentors of Community Servings.

His obituary called him pugnacious. Others, mostly those outside his district, called him difficult, insular, or intolerant. But for the residents of South Boston, the late city councilor **James E. Kelly's** lifelong home, he was a champion and a friend. Jimmy Kelly first rose to prominence when Boston was under a federal court order to integrate its public schools. The 23-year city councilor never changed his stance that the forced segregation hurt the city's school system and neighborhoods it was supposed to enhance, but his views on race mellowed over time. In 1999, Jimmy gave his support to a resolution to honor Martin Luther King Jr., an act, city councilor Charles C. Yancy told *The Boston Globe,* that "would have been unthinkable at the beginning of Mr. Kelly's career." In early 2007, the city named a bridge linking the South End to South Boston in honor of Jimmy Kelly.

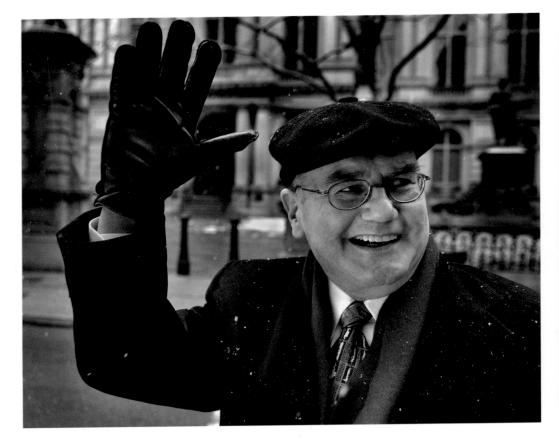

For brothers **John** and **Bert Jacobs** the statement Life is Good isn't just a philosophy for living well, it's a business strategy and the core of their casual clothing company of the same name—which *Inc.* magazine valued at more than $80 million in 2006. And while everything looks like smooth sailing today at the company's New Hampshire headquarters and its flagship store and offices on Newbury Street, it was through grassroots marketing that the brothers built their company into a worldwide brand. Yet they have shunned advertising and spent that money holding charity events like their famed Pumpkin Festivals.

When **Rosabeth Moss Kanter** talks, CEOs listen. Or they should. The Ernest L. Arbuckle Professor of Business Administration at Harvard Business School, Rosabeth specializes in strategy, innovation, and leadership for change. She is the award-winning author or co-author of 16 books, including the best-selling *Confidence: How Winning Streaks & Losing Streaks Begin & End.* A sought-after speaker and commentator, an adviser and consultant to CEOs around the world, Rosabeth continues to support several local community organizations including Urban Improv's violence prevention fundraising event, Banned in Boston.

If they seem like an unlikely pair to be changing the landscape for young people in Boston and Rwanda, that's OK with **Barry T. Hynes** and **Sister Ann Fox.** But you'd be wrong to underestimate their ability to get things done. The son of former Mayor John B. Hynes, a former city councilor and Boston city clerk, Barry is co-founder and executive director with Sister Ann of South Boston's Paraclete Center, an acclaimed after-school enrichment program for middle school students living in the projects. The duo was tapped by the Rwandan government to open a girls' school in the African nation. That rural education oasis is supported in part through Sister Ann's introduction of Rwandan coffee to the Boston area.

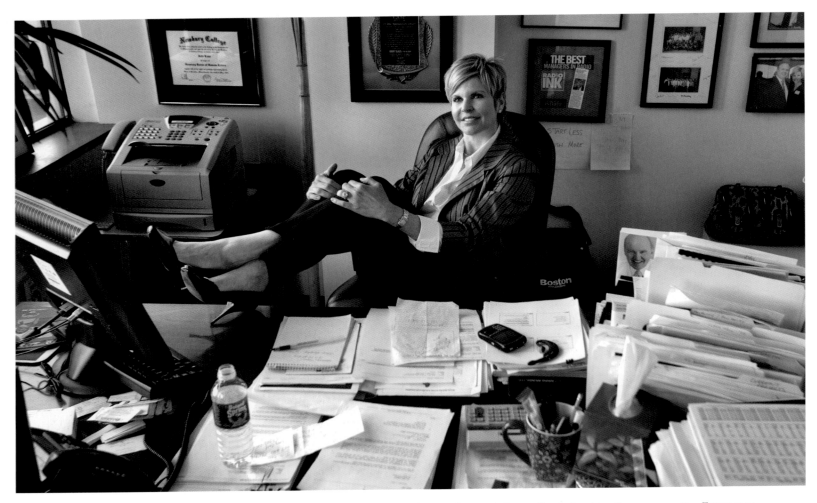

All most radio executives ever wish for is to have their stations and shows listened to and then talked about in the community. Entercom New England's vice president and market manager **Julie Kahn** may have got more than she bargained for. The eight AM and FM stations in the Entercom stable range from rock to sports with show hosts whose on-air comments and off-air actions were a news staple in 2006 and early 2007. But it's paying off for this pioneering radio executive and her stations, which retained the broadcast rights to the Red Sox, shifting most of the games from sports chat station WEEI to sister station WRKO, which beefed up its lineup in 2007 to include former House Speaker Tom Finneran along with the station's anchor, Howie Carr.

If you're looking for the cutting edge, you might want to ask **Gary Koepke** and **Lance Jensen** for directions. Founders of the Boston-based advertising agency Modernista!, these creators of campaigns for Cadillac, Budweiser, Napster, MTV, and Very Fine tread the outer edges of communication daily. Modernista! created the Product (Red) campaign with Bobby Shriver and U2 frontman Bono that was designed to raise not just brand awareness, but cultural understanding of issues. The "Choose Red" initiative seeks to help fund medication for AIDS victims in Africa. In 2006, Gary and a team of about 20 put in about 2,500 hours over a four-month period to create the video for U2's "Window in the Skies."

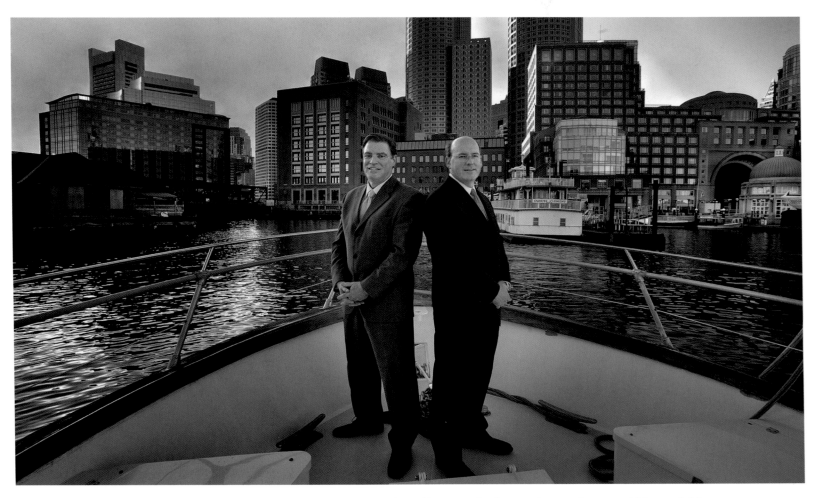

Just a few years ago, only the most imaginative person could have predicted how much of Boston's waterfront would be available to area residents and that there would be two luxury hotels anchoring the area that links the Financial District to South Boston's Seaport District. These two men have committed their professional lives to making that happen. **Timothy P. Kirwan**, managing director of the InterContinental Hotel, is a veteran in the region's hospitality industry, who opened the newest spot on the block in late 2006. **Paul Jacques** has been general manager of the Boston Harbor Hotel since 1993. As the warmer weather finally arrived in 2007, Paul and his staff were able to show off the famed building with its arched walkway to the waterfront, having weathered years of Big Dig construction and other projects along Boston Harbor.

**Edward P. Kelley,** president and CEO of the child welfare agency the Robert F. Kennedy Children's Action Corps, has spent more than four decades working with at-risk youths. As a *Boston Globe* profile pointed out, Ed has no specialized degrees, but the Cambridge resident is highly-regarded in the field of social work and is credited with helping thousands of young people turn their lives around. In early 2007, Ed was honored for his 25 years of service with the Action Corps, where he started in 1981 as a deputy director. Ed not only works with those in crisis, but he is an advocate for ensuring that all young people can pursue an education.

Cleve L. Killingsworth, president and CEO of Blue Cross Blue Shield of Massachusetts, and Peter Meade, an executive vice president, are involved in a dizzying array of community and civic organizations. But these two men never lose sight of their real mission: to ensure that all the state's residents have access to quality health care. An alumnus of the Massachusetts Institute of Technology, Cleve joined Blue Cross Blue Shield in 2004 as the company's president and COO, and became CEO in July 2005. A former radio talk show host at WBZ, Peter has held a variety of positions in the area including president of The New England Council. Among Peter's civic commitments is his chairmanship of the Rose Fitzgerald Kennedy Greenway Conservancy. And in May 2007, Peter was named chairman of the Emerson College Board of Trustees.

Michael J. Kineavy knows the city of Boston better than most people know their backyards. Michael is Mayor Thomas M. Menino's chief of policy and planning, but has held other posts in his 14 years with the city including running the Office of Neighborhood Services. In 1997, Michael took over the Employee Assistance Program, which provides free substance abuse and mental health services for city workers and their families. Helping those in need is something he has championed on the hard-scrabble streets of his native South Boston. Michael's political savvy was extended beyond the city to being part of the 2000 election recount team in Florida, to Northern Ireland and Romania.

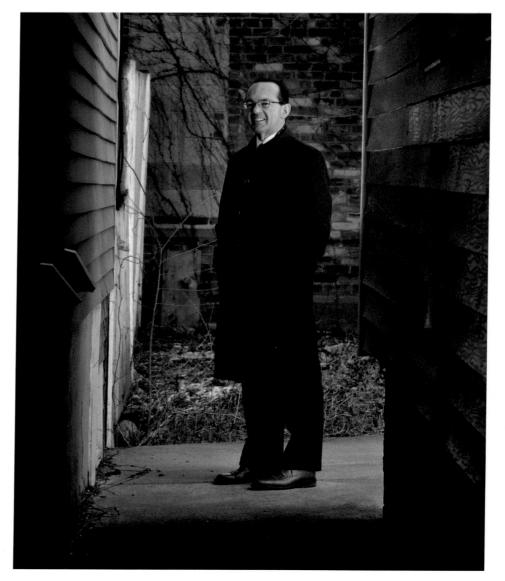

Ladies and gentlemen, let us introduce you to some of Boston's most successful fund-raisers: **Darlene Jordan, Simone Winston,** and **Patricia Ribakoff.** The 2005 Storybook Ball shattered records for a Boston gala raising more than $2.5 million for the MassGeneral Hospital for Children. One auction item alone, all 424 Green Monster seats for a game, went for a whopping $200,000. But don't be fooled, these aren't the "ladies who lunch" of old. Their fundraising ranks include lawyers, MBAs and business leaders, and they are active in many organizations including the Boys and Girls Clubs of Boston, Combined Jewish Philanthropies, and United Way of Massachusetts Bay.

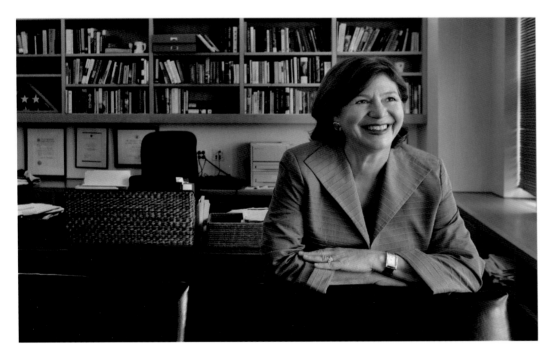

The lessons she learned and the history she witnessed while working as a Pulitzer Prize–winning reporter for *The Boston Globe* formed the framework **Maria Karagianis** used when founding Discovery Justice in 1998. Covering issues like racial clashes in Boston and the fight for equality among those living in South Africa are central to the organization's mission today. Originally a one-person operation, it has grown into a nationally recognized democracy education organization. Discovering Justice creates experiential education—plays enacted in courtrooms about American Constitutional history—as a way to strengthen democracy by training young people in the values, skills and history of democracy.

Born into the country's preeminent political family, **Matt** and **Joe Kennedy,** twin sons of former Congressman Joseph P. Kennedy II, have started to make their own way. Matt ran his great-uncle Edward M Kennedy's re-election campaign and was aided in the effort by his brother Joe, who has recently returned from a stint in the Peace Corps. These Stanford-educated fraternal twins are now at Harvard, where Matt is studying business and Joe is taking up law.

Yousuf Karsh's powerful images of
Winston Churchill, Georgia O'Keeffe,
George Bernard Shaw, Audrey
Hepburn and Ernest Hemingway
cemented his place as one of the
greatest portrait photographers. His
widow, medical historian and jour-
nalist **Estrellita Karsh,** has ensured
that his legacy will not only be as an
important twentieth-century artist,
but as a generous and nurturing
man. It was during his days as a
young apprentice in Boston that
Yousuf began his relationship with
the Museum of Fine Arts, which he
would later call "my university." The
site of his first museum exhibition,
the MFA now has a photography
curator's position endowed by the
couple and bearing their name.
Their generosity extends to organi-
zations around the world and other
institutions in Boston. One of the
most obvious of these is Brigham
and Women's Hospital, where twenty
of Yousuf's portraits of important
scientific and medical figures—
including this stunning portrait of
Albert Einstein—have been installed
on the hospital's Nesson Pike, which
has been called "a gallery that never
closes."

At the start of her nationally syndicated television show, former Massachusetts Superior Court Judge **Maria Lopez** says, "Talk about the American dream. . . . I am the American dream." When this former adjudicator came to the United States from her native Cuba at age eight, she was unable to speak a word of English. There is an irony in her TV career, this mother of two notes. She resigned from the bench after a seconds-long loss of decorum caught on tape—"Sit down or I will have my court officer sit you down!"— that ultimately led to her getting her own courtroom TV show. Which explains why this success story has named her company Sit Down! Productions.

It really is a secret family recipe. In 1985, Boston Beer Co.'s founder and brewer **Jim Koch** launched the Samuel Adams brand with Boston Lager on Patriots' Day. The brew was reformulated from a recipe his great-great-grandfather developed in St. Louis in the 1860s. Just three months after it debuted, the lager was voted best beer in the country at the Great American Beer Festival. Brewed in Jamaica Plain, with the help of brewing companies around the country, Jim has expanded the brand to include ten year-round varieties with regular seasonal additions. Now that secret family recipe has become a staple far beyond the land where Samuel Adams made history.

For Boston philanthropist **Barbara Lee**, the idea of a female president isn't so farfetched. It's a problem that can be solved through support and fundraising. Even before New York Senator **Hillary Clinton** announced she was running for president, Barbara supported female candidates at all levels of government through her Barbara Lee Family Foundation Women in Politics Program. Barbara's other long-held dream of having a new Institute of Contemporary Art in Boston became a reality in fall 2006. Her family foundation donated more than $5 million to the project and the ICA's theater, with its sweeping views of Boston Harbor, is named in its honor.

Friendships are hard to maintain in today's busy world, but not if you work on keeping a set time to get together. That's the case for **Robert Lewis Jr.** and **Jeffrey Swartz**, two very high-profile locals who are just regular guys at Santarpio's Pizza in East Boston. Robert is the executive director of Boston Centers for Youth & Families, which runs 46 facilities in the city. Jeffrey, who is rarely photographed without a Red Sox cap, is president and CEO of Timberland, one of the country's fastest growing companies, which has regularly been named to industry lists, including *Fortune* magazine's Best Companies.

When the food world talks about the beginning of Boston's restaurant golden age, it usually starts with **Michela Larson** opening her eponymous eatery in East Cambridge in 1985. Michela transformed space in the former Carter Ink Factory into an Italian restaurant that dared to serve squid ink ravioli and had "no red sauce" dishes on the menu. Chefs who got their start at Michela's include Todd English, Barbara Lynch, Suzanne Goin, Jody Adams, Ruth Anne Adams, and Laura Brennen. A founder of Community Servings, Michela would later open Rialto with Jody Adams, followed by blu and Noir. In April 2007, Michela returned to her roots with the opening of Rocca in a former factory in the South End.

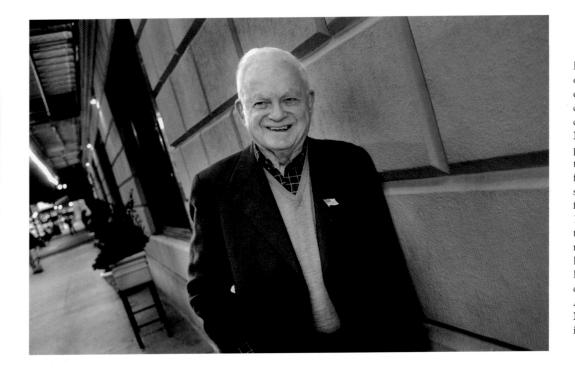

If the families of fallen police officers or firefighters in the Boston area ever need anything, they know they can call upon **Norman Knight.** As a co-founder of The Hundred Club of Mass. Inc., Norman has made it his priority to see that those who give their lives in the line of duty are not forgotten by the communities they serve. A broadcaster by trade, he founded Knight Quality Stations in 1959 but now devotes all his time to charitable work. For his commitment, the Leary Firefighters Foundation donated a modified Boston whaler to Boston's fire department in Norman's name. A hyperbaric chamber at the Massachusetts Eye and Ear Infirmary is named in Norman's honor.

When former Governor **Edward J. King** died on September 18, 2006, it marked the passing of the man who many said most reflected Massachusetts politics of the late 1970s and early 1980s. A one-time Democrat who beat incumbent Governor Michael S. Dukakis in the 1978 primary—only to lose to Dukakis in the 1982 primary—King switched his party affiliation in 1985 to Republican, which King said better reflected his political beliefs. That move attracted the attention of then president Ronald Reagan, who called to congratulate the former state leader.

Beth Israel Deaconess Medical Center's **Paul Levy** is a president and CEO who has faced many challenges. He's a former executive director of the Massachusetts Water Resources Authority and is former executive dean for administration at Harvard Medical School. But nothing could have prepared him for being the first hospital administrator in the area to have a blog where he fields queries that range from the quality of paper towels at his facility to posting the infection rate on-line. Nothing, except coaching soccer for 12- and 14-year-old girls in Newton. He also referees and plays with a co-ed group. "Soccer is life," he says.

Late-night comic **Conan O'Brien** came back to the area in the fall 2006 to help his one-time Harvard housemate and fellow Brookline native **Rev. Paul B. O'Brien**, pastor of St. Patrick's Church in Lawrence, open the 5,600-square-foot Cor Unum Meal Center. Even before coming to Lawrence, Conan supported the effort to build the center in the parish of the priest who is a friend but not a relative. The $1.5 million needed for the center, which takes its name from the Latin for "one heart," was raised through the website labelsareforjars.org, which sells T-shirts with labels designed by Conan, Detroit Tigers first baseman Sean Casey, and others.

Even if he hadn't been the subject of an aggressive attack with an American flag on City Hall Plaza in 1976, **Ted Landsmark** would still be among the city's most important leaders. Now the president of the Boston Architectural Center, Ted was thrust into the public consciousness when he was set upon by anti-busing protestors and the moment was captured by two-time Pulitzer Prize–winning photographer Stanley J. Forman. Ted would later tell a writer from *Smithsonian* magazine that just moments after the incident he knew that something significant had happened and his course had been forever altered. The Yale-trained lawyer would work for Boston mayors Raymond L. Flynn and Thomas M. Menino. As the head of the Boston Architectural Center, Ted has been outspoken about not just the city's buildings, but those who inhabit them. Among his concerns is the leadership vacuum in the city that has followed the corporate exodus of the last several years.

Before there was instant messaging or news alerts sent directly to cellphones, there was **Gary LaPierre** who announced the news and held court on WBZ-AM (1030) each weekday morning for nearly 43 years. He covered the hard, tough news that hit the region and had a little fun with the lighter stories before his retirement at the end of 2006. With every snow storm each winter, the area's children would listen as he rattled off the school closings, prompting night-time talk host Paul Sullivan to call Gary "the voice of happiness."

Yes, they really are brothers, they know a lot about cars, and they operate a successful garage in Cambridge. But no, their names are not "Click and Clack, the Tappet Brothers" and they absolutely do not rehearse their shows or research their answers in advance. For 20 years, **Tom** and **Ray Magliozzi** have been holding forth on all things automobile-related on their popular syndicated weekly NPR show, "Car Talk." These MIT grads are heard on nearly 600 stations nationwide and on the internet, and write a syndicated column. Part car show, part therapy session (for both the hosts and the listeners) and just good old-fashion fun, "Car Talk" explores what makes both cars and drivers

**Ronald C. Lipof** is president and CEO of The Wellness Community–Greater Boston, a nonprofit organization providing free support, education and hope to people with cancer and their loved ones. Chosen by the *Boston Business Journal* in 2002 for a "40 Under 40" award, this government relations graduate from Boston University is a member of Governor Deval Patrick's Business Cabinet. The interest and commitment to public service runs in the Lipof family. Ron's late father, Michael, was an alderman in the City of Newton, and two of his siblings, Rick and Cheryl, serve as Newton aldermen. His mother, Rabbi Emily Lipoff, is the former senior rabbi at Temple Ohabei Shalom in Brookline.

When Hollywood came knocking on the door of **Thomas A. Kershaw's** Beacon Hill pub in 1982, this chairman and CEO of Hampshire House Corp. was ready. Tom already had a decade of experience running an eatery in the historic house and the Bull & Finch Pub downstairs. But not even someone with Tom's exuberance for entertaining people could have imagined what effect the hit television show *Cheers* would have on the little pub on Beacon Street and on the city itself. The show and the pub that inspired it became so intertwined that Tom changed the pub's name to that of the show. Now Cheers, the place "where everybody knows your name," is a name everyone knows.

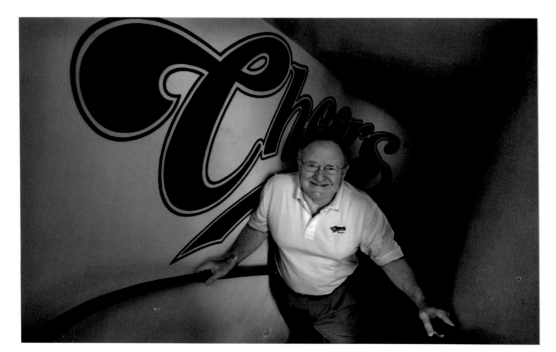

A pioneer of American regional cuisine, **Jasper White** won a James Beard award in 1991 and his Jasper's restaurant was one of the region's most popular during its 12-year run. But the owner of Jasper White's Summer Shacks is not a food snob. The chef, who the late Julia Child called her "all-time favorite," has served as a mentor to countless people in Boston's food world. One of those is **Dave Littlefield**, better known as The Sausage Guy. The two met at a charity event and, on Red Sox Opening Day 2007, Jasper worked his fifth year of helping Dave serve sausage, onion and pepper sandwiches.

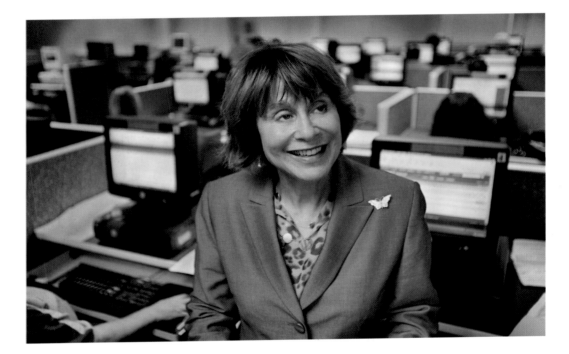

**Barbara Rosenbaum** knows what works and who doesn't. She's the president and CEO of Jewish Vocational Services, a nonprofit, nonsectarian organization that has served the greater Boston community for more than 60 years. In 2005, Barbara was appointed to the advisory board of the state's Workforce Training Fund, which provides resources to Massachusetts employers to train their staff as a way to build the strength of the state's businesses. She has served on the Massachusetts Workforce Investment Board and the Workforce Development Coalition. And she shares the lessons she's learned. Barbara frequently testifies on Beacon Hill and Capitol Hill on workforce development issues.

As president of Emerson College, **Jacqueline Weis Liebergott** is the first woman to serve in that capacity since the university's founding in 1880. Jackie knows a few things about firsts. She taught the first women's studies course offered at Emerson. She later would serve in a variety of administrative positions, including interim president, before being named president in 1993. Under her leadership, Emerson rebuilt itself near the Boston Common and is credited with spurring the ongoing rebirth of Boston's Theatre District. She is a founding member of the Boston Arts Academy, the city's first high school of the arts, and is a leader in Boston's Professional Arts consortium.

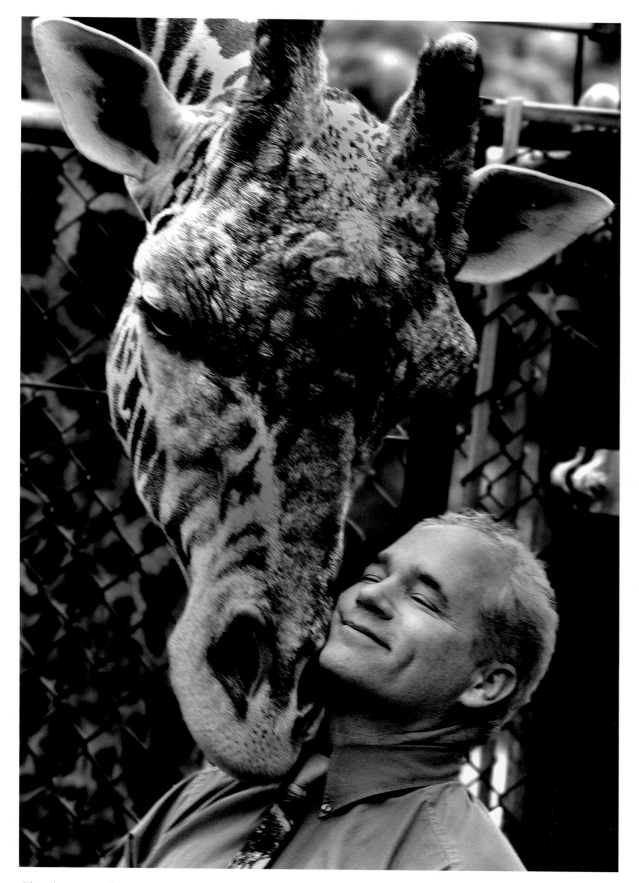

There's no mistaking Beau, a male Masai giraffe, who watches over his corner of the Franklin Park Zoo with a graceful majesty. Nor is there any question about the affection that **John Linehan**, president and CEO of Zoo New England, has for the 18-foot quiet wonder and his mate Jana, considered to be two most genetically valuable giraffes in captivity in North America. Some say John knows the Franklin Park Zoo and the Stone Zoo in Stoneham from the ground up. Perhaps that's because he started at the Franklin Park facility in 1981 as a laborer and over the next 25 years he worked in nearly every job at both zoos.

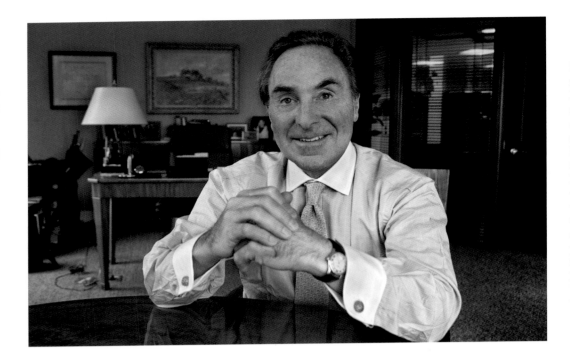

In 1974, **Jack Manning** and his partner Herb Collins created their Boston Capital Corporation in a spare bedroom. Jack is now president and CEO of a company that is acknowledged as one of the nation's leading real estate financing and investment firms, with multi-family housing and commercial holdings in 48 states. *Forbes* magazine called the Fall River native "scrappy," but others have lauded his visionary management. Jack is the son of a pediatrician who treated special-needs children and took care of Manning's mother, a polio patient. He's involved in a variety of charitable and civic organizations in Boston.

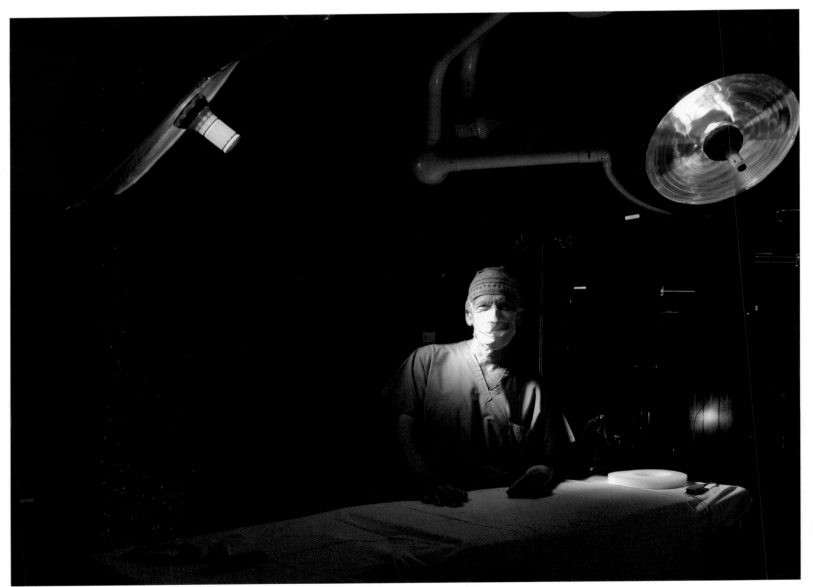

As the president and CEO of Children's Hospital Boston, **Dr. James Mandell** has worked tirelessly on behalf of the young patients at his facility. As a leader in the medical community, this professor of surgery at Harvard Medical School has been an outspoken advocate for all the city's hospitals and the clients they serve. But the community leader and physician worked to help halt the escalating neighborhood violence that was claiming the lives of so many of the city's young people. "In my experience, the kind of major commitment Dr. Mandell and Children's Hospital Boston made this year to help stanch the violence impacting Boston's inner-city youngsters is unprecedented," said ABCD president and CEO Robert M. Coard.

Robert M. Mahoney is vice chairman of Citizens Financial Group, responsible for commercial banking across Citizens' 13-state franchise. He also oversees Government Banking, Commercial Insurance, and Investment Management Services. He is actively involved in the Boston community, serving as chairman of the United Way's board of directors, board member of The Boston Main Streets Foundation, and trustee of Catholic Charities. But it's his interest in cooking and old Corvettes that provided the fodder when Bob was the guest of honor for the Whittier Street Health Center's 13th annual roast to benefit the nonprofit community center in Roxbury.

When Carole Simpson started as Leader-in-Residence at Emerson College in early 2007, it was an aptly named appointment. A three-time Emmy Award–winning broadcast journalist, Carole brought her four decades of experience to the Back Bay college. She joined ABC News in 1982, and served as ABC's weekend anchor for 15 years. Her daughter, Dr. Mallika Marshall, MD, is on a path carved out by her mother. The medical reporter for WBZ-TV is a pediatrician and an internist. Her practice at the Massachusetts General Hospital–Chelsea Urgent Care, treats both children and adults.

He was given the title of "Mr. BC" and there seems no better description for Dr. James P. McIntyre. A senior vice president at Boston College, Jim's connection to the Jesuit school began with his arrival as a freshman from Malden Catholic High School. During his nearly 50 years of service, there is scarcely a significant university issue in which he has not been personally involved, including the stadium expansion and the construction of a student recreational complex. The only things Jim holds closer to his heart are his wife, Monica, and their six children, all of whom are Boston College graduates.

Like so many before her, it was a new job and a chance to advance her education that drew **Ellyn A. McColgan** to Boston. Although this New Jersey native and daughter of a steamfitter now could have her pick of posts, Ellyn continues to be among the city's most accessible business leaders. Ellyn has worked with Fidelity Investments since 1990 and was a much-hailed president of Fidelity Brokerage Company before she was promoted in April 2007 to president of distribution and operations, where she oversees nearly half of the company's 42,000 employees. A graduate of Harvard Business School who first came to the Boston area in the early 1980s, Ellyn has supported numerous civic and charitable groups, including serving as an overseer of the Museum of Fine Arts and on the President's Council of Massachusetts General Hospital.

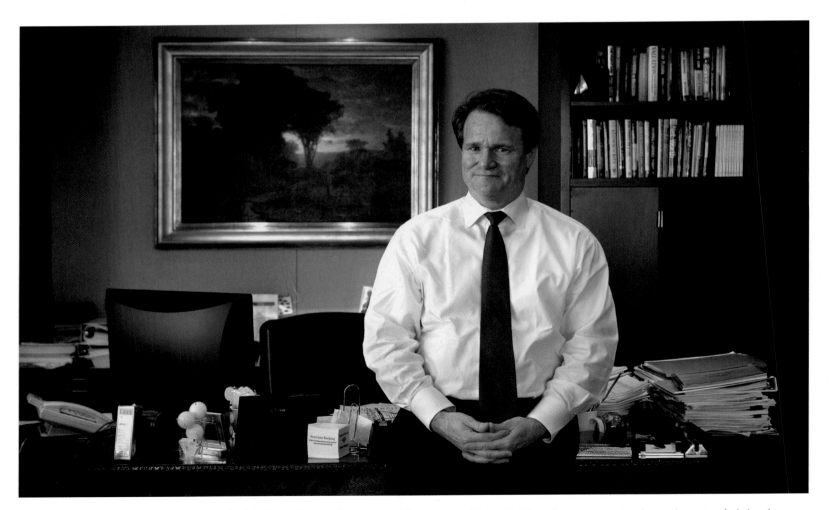

Bank of America's President of Global Wealth and Investment Management **Brian T. Moynihan** is an outspoken advocate of philanthropy as a wise investment, noting that the support given by the wealthiest Americans changes lives each day. A veteran of New England's banking industry, Brian practices what he preaches. He's on the board of directors for the Boys and Girls Clubs of Boston and the United Way of Massachusetts Bay. As a member of the board of directors for YouthBuild Boston, Brian doesn't just attend meetings or raise money. He's been known to don a hard hat and roll up his sleeves in support of YouthBuild Boston's academic and vocational training programs for young people ages 7 to 24.

Determined that their friends would not be forgotten, Vietnam veteran **Tom Lyons** and a few of his South Boston comrades-in-arms worked with their community to erect one of the first memorials to commemorate the loss of South Boston's 25 fallen servicemen. The stone monument was dedicated on September 13, 1981—a full year before the granite panel walls of the Vietnam War Memorial in Washington, D.C., were unveiled. At the bottom of the large rectangular stone in South Boston are the words: "If you forget my death, then I died in vain." That's something Tom and his fellow veterans have not let happen in South Boston.

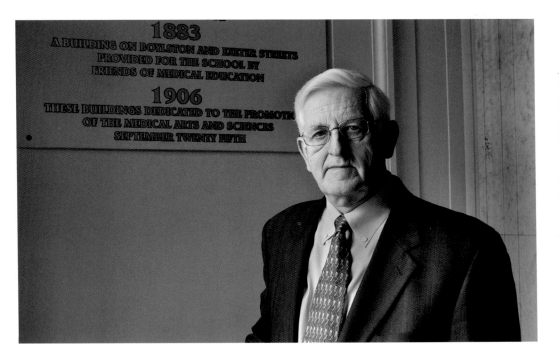

A neurologist and neuroscientist by training and the former chief of the neurology service at Massachusetts General Hospital, **Dr. Joseph B. Martin, MD,** was recruited to Harvard Medical School to be its dean in 1997. He is credited with fostering collaboration, interdisciplinary research, diversity, and the highest standards in research, and oversaw the medical school during one of the greatest periods of transition in Boston's heath care marketplace, particularly for the Harvard-affiliated hospital. After more than nine years as the Dean of Harvard University Faculty of Medicine, Joseph announced plans to step down from the position in July 2007.

**Patrick B. Moscaritolo** and his staff at the Greater Boston Convention & Visitors Bureau represent some 1,200 businesses in New England. As the primary marketing and visitor service organization responsible for developing convention and tourism business in Greater Boston, they have a simple—if not easy—job. That is, get as many people as possible to come to Boston, enjoy themselves, learn something, spend money, eat great food and want to return to the city again sometime soon. As president and CEO of the bureau, Pat serves on several boards, including the Massachusetts Sports & Entertainment Commission.

When **John A. Nucci** was named
Suffolk University's vice president of
government and community affairs
in late 2005, it brought his career in
public service full circle. An elected
official in the city of Boston for 20
years, John served four years as an
at-large member of the City Council.
It was his service on the School
Committee, in its hardscrabble days
when the members were elected,
that John made his name. Not only
did he serve for six years on the
committee, he was its president for
four of them. Prior to joining Suffolk,
John was the elected clerk of Suffolk
County Criminal Superior Court for
11 years.

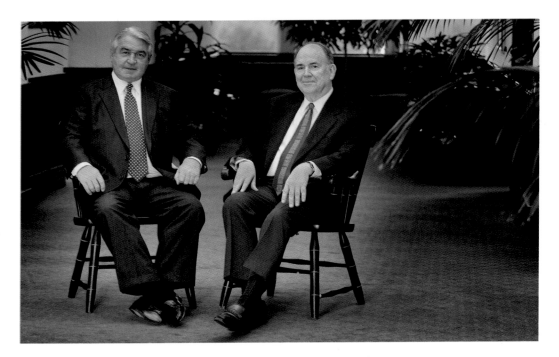

Boston Scientific's story began in the
late 1960s, when co-founder **John
Abele**, right, a scientist by training,
acquired an equity interest in Medi-
tech, Inc., a company focused on
developing alternatives to traditional
surgery. He met businessman **Peter
Nicholas** at a kids' soccer game in
1979; the two partnered to buy
Medi-tech and formed Boston Scien-
tific Corp. Since its public offering in
1992, Boston Scientific acquired a
portfolio of 15,000 products. The
founders have since stepped down
from daily management, although
Nicholas remains chairman and
John serves as a director. In May
2007, Peter and his wife, Ginny,
came forward as the previously
anonymous donors of $10 million to
the Boys and Girls Clubs of Boston.

As Founder and Chairman of Q10 |
New England Realty Resources,
**James M. Murphy** heads one of the
region's leading mortgage banking
firms. Jim's commercial real estate
experience includes more than $2.5
billion in transactions. He has held
several national positions, including
former chairman of the Mortgage
Bankers Association of America
where he is on the board of direc-
tors. He also is a former member of
Fannie Mae's National Advisory
Council. Locally, Jim was a member
of the mayor of Boston's Housing
Finance Blue Ribbon Panel. He is a
member of the Board of the Francis
Ouimet Scholarship Fund, the
largest independent scholarship
organization for students working
at Massachusetts golf courses.

Best-selling author **Ben Mezrich** couldn't have written it any better himself. As 2007 began, the big screen adaptation of his *Bringing Down the House: The Inside Story of Six M.I.T. Students Who Took Vegas for Millions* was being made. Not a small production, the film features Oscar-winner Kevin Spacey, Cohasset's Kate Bosworth, and Laurence Fishburne, and was shot on location in the Boston area for several weeks. The author of eight books, Ben started out writing fiction, but with *Bringing Down the House* he smoothly transitioned into non-fiction. Ben's next book, about the world of oil and young traders, is due to be released in October 2007. He also has had a couple of steady television gigs and has hosted a reality show about the dark lives of young hotshots on Court TV and blackjack shows on GSN.

During one of world-renowned cellist **Yo-Yo Ma**'s many appearances at Symphony Hall, a member of Boston Symphony Orchestra's board of trustees mentioned to a reporter that she hoped the people of Boston never took for granted what a treasure it is to hear the music of such a virtuoso. While that would be unforgivable, Boston audiences can be forgiven if we have come to think of Yo-Yo as one of our own. A Boston area resident when he's not traveling the world for performances, Yo-Yo is a champion of young musicians and is regularly seen on stages—big and small—in the Boston area.

**Richard Serino** began at Boston Emergency Medical Services in 1973 as an emergency medical technician, and he worked his way up through the ranks before becoming Chief of Department in 2000. In addition to being responsible for all the uniformed members of the department, Rich has served for more than ten years as the Incident Commander for the region's biggest celebrations, including the Boston Marathon, the annual July Fourth fireworks and concert on the Esplanade, and Boston's First Night celebration. He's a committed public official working to improve the city's response to disasters by working with the US Department of Defense and others. He is training the next generation as well by working with Boston University's School of Medicine, and the Armenia Medical Partnership Program, which seeks to improve emergency preparedness in Armenia, Estonia and Moldova, and as a lecturer at the Boston University School of Public Health.

**Thurman "Jack" Naylor** is the owner of the world's largest collection of cameras and photographs—more than 30,000 catalogued items—and is considered to be one of the nation's foremost authorities on photographic history. Jack accumulated the massive collection, which he houses in this climate-controlled basement museum, over 55 years. A former Air Force test pilot, Jack built his fortune by inventing an automotive thermostat in the 1960s and came to the area to take over Waltham-based Thomson International Corp. His collection, which includes Civil War photos and espionage devices used by carrier pigeons during World War II, is on the market for $20 million.

Academy Award-winning actress **Meryl Streep** rounded out a two-day visit to Boston in April 2006—during which she was honored for her vast career—with a stop at the New England Regional Spinal Cord Injury Center's annual gala. Streep paid tribute to late actress Dana Reeve, who led the Christopher Reeve Foundation and worked on behalf of those with spinal cord injuries until her death from lung cancer at age 44. Representing her late sister was Boston area resident **Dr. Deborah Morosini,** who received her medical degree from Boston University Medical School and completed her residency in pathology at Boston Medical Center, and now works in the field of translational medicine.

Edward J. Merritt is a bit of a throwback, an old-school banker who actually knows a number of his customers by name. As president and CEO of Mt. Washington Bank, Ed oversees one of the oldest and fasting growing community banks in Boston. Since his appointment in 1999, Mt. Washington Bank has grown into a full-service financial institution. But the bank and Ed haven't forgotten the communities that built it. In 2002, Ed founded the Mt. Washington Charitable Foundation, which dedicates 10 percent of the bank's annual profits to nonprofit organizations that support educational, youth and cultural programs.

Just steps from the hustle and bustle of Downtown Crossing, Michael Bennett gets a flu shot from Dr. James O'Connell and registered nurse Cheryl Kane, part of the "Street Team" at the Boston Health Care for the Homeless Program. Jim is president of the citywide program that has as its mission providing the highest quality health care to homeless men, women and children in metropolitan Boston. Begun in 1985, the program has clinics at Boston Medical Center, Massachusetts General Hospital, and Lemuel Shattuck Hospital, as well as direct-care services at more than 70 shelters, soup kitchens and community sites where homeless people gather.

Michael G. Olivieri, publisher of the Boston Business Journal, and editor George Donnelly lead a weekly publication that tracks the area's growth companies and the people who lead them. They also are the keepers of the much-anticipated, often-saved weekly lists ranking particular area industries. Annually, the paper's parent company publishes the Book of Lists and to be left off is to risk being lost in the city's shuffle for a year. George joined the BBJ in 2000 after working for two years as senior editor of CFO magazine. Mike also is responsible for publishing Mass High Tech, the Journal of New England Technology. He serves on numerous local nonprofit boards.

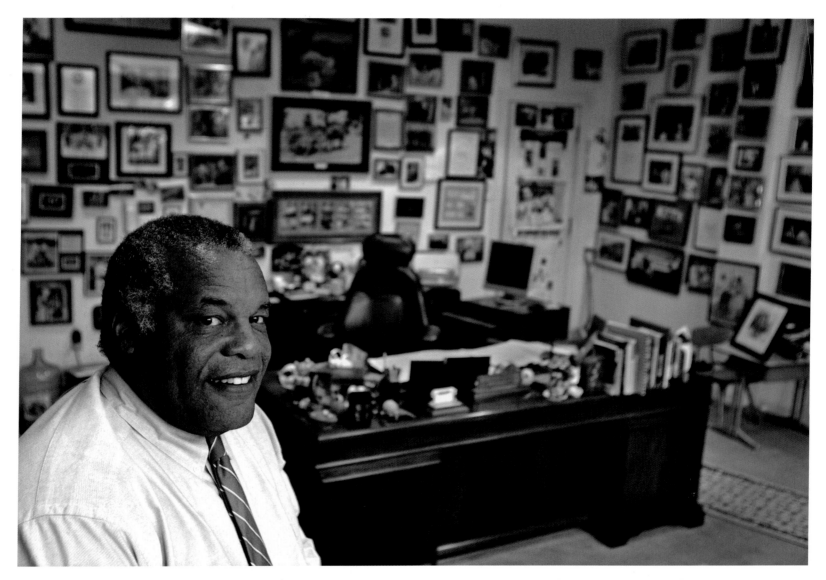

If you want to find **Edward O. Owens** and his wife, Maureen, at a charity event like the Jimmy Fund's annual telethon, you'll want to look beyond the glare to the bank of telephones. Not one for the spotlight, the president and CEO of The Owens Cos. is known in Boston as a "doer." The company was founded in 1927 by Ed's dad, Henry F. Owen Jr., the youngest of 18 children of a blacksmith, with $50 he borrowed to buy a horse and buggy to haul ice and coal from Boston's piers over the river to Cambridge. As the story goes, Henry expanded into household moving and would later move pianos for Arthur Fiedler at Symphony Hall and Tanglewood, and was trusted with transporting Raytheon's first microwave oven. Today, the company is run by Henry's youngest son, and once again it has expanded to one of the largest commercial moving companies in Boston. The Owens Cos. are the go-to movers for some of the city's biggest movers and shakers including Gillette, Fidelity, State Street, Northeastern University, and Harvard University.

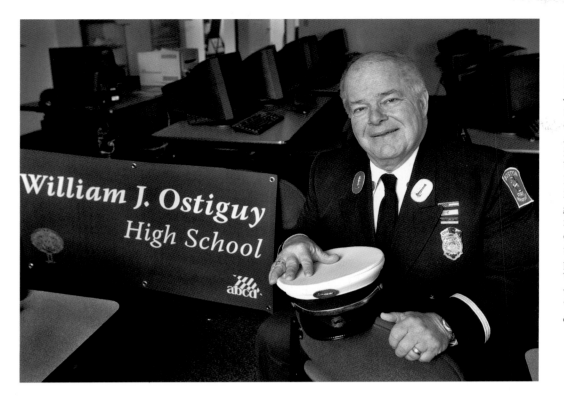

Like so many firefighters, Boston Fire Department Lieutenant **William J. Ostiguy** is known for helping those in a crisis. But as the director of the department's Employee Assistance Program, Willy aids those facing a less obvious need. Through Willy's lobbying, the first Recovery High School was set up in Boston in 2006 with a $2.75 million state grant. The school that bears his name gives students who are recovering from substance use a chance to finish their education in a supportive and drug-free environment. When word came that the school would be a reality, Willy said simply: "This is about giving kids a real chance."

There once was a wee place on Province Street where opening the only door could cause the entire bar to move. The Littlest Bar was never bigger than its name. Irishman **Paddy Grace**, proprietor since 1990, hosted lawyers, laborers and retailers as they spoke of their day while jockeying for just a little more room. Paddy is seen here talking to **Jim O'Brien**, the former president of the Ireland Chamber of Commerce in the United States. When the bar closed at the end of 2006, Paddy looked to Celtic mythology, stating that, like the Phoenix, The Littlest Bar would rise from the ashes.

Their name has long been associated with development in Boston, but now the **Pappas family** is at the vanguard of the city's "green" building movement, where living space is designed to use less energy and cause less of a strain on the environment. Shown in the courtyard inside the Court Square Press Building in South Boston that Pappas Enterprises opened in 2004, they are **P. Andrew; Alexandra; Jim,** chairman of Pappas Enterprises, Inc.; **Jay;** and Pappas Enterprises CEO **Tim.** The charitable organizations the family supports, which are as diverse as the designs of the structures they build, include Artists for Humanity, Dana-Farber Cancer Institute and Rosie's Place.

Just about 12 hours after the new administration was sworn in at a historic State House ceremony, Governor **Deval Patrick,** his wife, **Diane,** Lieutenant Governor **Timothy P. Murray** and his wife, **Tammy,** were still reflecting the energy and enthusiasm that marked their campaign. The inaugural ball came at the close of a day of events that included a prayer breakfast, an event for young people, and a black-tie gathering at the Museum of Fine Arts. But even that wasn't the close of the first day in office. Before the newly installed leaders left the Boston Convention & Exhibition Center, the governor gave notes to his staff, which had its first meeting shortly after the ball ended.

An architect by training, a developer by profession, Millennium Partners–Boston partner **Anthony Pangaro** is a patron of the arts at heart. Recent projects in Boston's Back Bay and downtown include 10 St. James @ Arlington, the 1.8 million-square-foot Ritz-Carlton Hotel and Towers, and One Charles, a luxury condominium tower in Park Square. He was the manager of the state's $1 billion Southwest Corridor transportation and redevelopment project. But most in the community know Tony from his service on several nonprofit boards, including the Boston Conservatory of Music, the Boston Center for the Arts and the American Repertory Theatre.

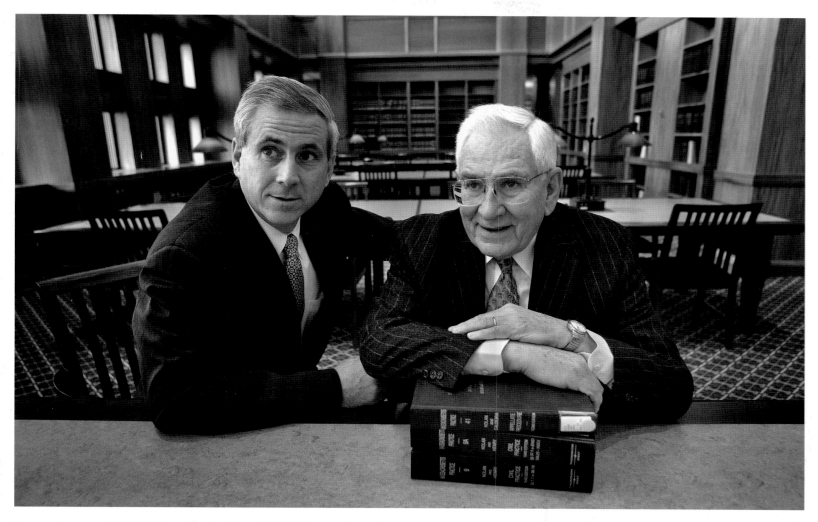

Former Supreme Judicial Court Justice **Joseph R. Nolan** may have been an attorney since 1954, but that doesn't mean this former litigator, prosecutor and municipal court judge isn't still studying the legal system. In the early 1970s, Joe was the general counsel for the newly formed Massachusetts Lottery Commission. He served in several judicial positions before his appointment in 1981 to the state's highest court. Since his retirement in 1995, Joe has been a professor at Suffolk Law School. Joe's son **Joseph R. Nolan Jr.** shares his name and passion for Boston, but is one of the few non-lawyers in the family. He is senior vice president of customer and corporate relations for energy company NStar. Joe has represented his company on several task forces at both the state and municipal level.

The law seems to pump through the Murray family's veins. Brothers **Robert** and **Vincent A. Murray Jr.**, center, are partners in Murray and Murray, just a few paces from the Suffolk County Courthouse. Bob's son **Michael**, at left, is a student at Suffolk Law School, and Vin's son **Stephen,** at right, is a partner in the firm. Bob's been a sports attorney for more than 30 years, representing professional hockey players. An attorney for more than 35 years, Vin handles personal injury and workers' compensation cases. Outside the courtroom, Vin has been very active in youth baseball in Hingham, where he has coached for 30 years.

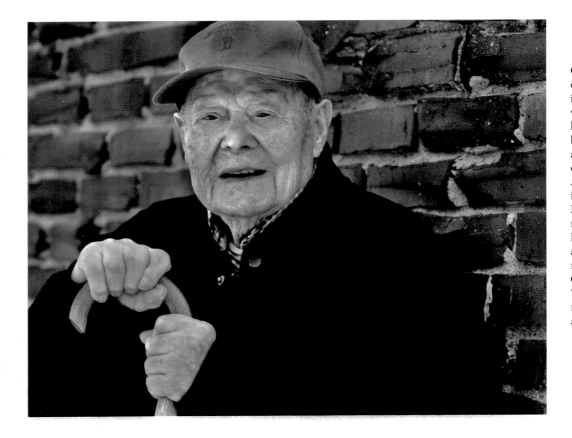

Considered the state's last living veteran of World War I when he died in February 2007, **Antonio Pierro** was just a week shy of celebrating his 111th birthday. Antonio was believed to be the oldest American and one of the last eight US veterans of World War I. Born in Italy, Antonio came to the United States in 1914, ultimately settling in Marblehead. Although he had witnessed some horrible events during his eighteen months of service as an artilleryman in the US Army, his nephew Rick Pierro told *The Boston Globe* that Antonio was always "an old-fashioned sweetheart, a real nice, gentle soul who always enjoyed a smile."

**Dr. Elizabeth Pomfret, MD,** and her husband, **Dr. James Pomposelli, MD,** have dedicated their careers and a substantial amount of their own time to advancing the science of live-donor liver donations. Director of the Live Donor Liver Transplant program, Elizabeth is an assistant professor of surgery at Lahey Clinic Medical Center, where James is senior staff surgeon and an assistant professor of surgery. Their team was the first to perform a live-donor liver transplant on adults in New England, and their program is the third largest in the United States. These doctors also founded the nonprofit Thalia House in Carlisle, which supports live-donor liver transplantation patients, donors and the families of both.

What these two have done with the English language! **Tina Packer** is a founder of the acclaimed Berkshire theater troupe Shakespeare & Co., which had Edith Wharton's famed home The Mount as its headquarters and performance space for many years. When other companies were folding their tents, Tina took her merry band up the road to a former boys' school in Lenox, which has been the company's home since 2001. A Brookline native, **Mike Wallace** was a correspondent on *60 Minutes* from its premiere on Sept. 24, 1968, until the end of the 2005–2006 season. A newsman since the 1940s, Mike still contributes to CBS News programs. The two are shown at a gala for Shakespeare & Co. in the fall of 2004.

**James J. Pallotta** is one of Boston's most philanthropic citizens. A managing director for Tudor Investments, Jim is one of the most successful hedge fund managers in the country. A part owner of the Celtics, this North End–bred financial whiz eschews headlines and quietly throws his support behind a host of civic and cultural organizations. They include Berklee College of Music, Big Brothers Big Sisters of Massachusetts Bay, Boston Children's Hospital Trust, the Institute of Contemporary Art (where there's a gallery in Jim and wife Kim's name), Red Auerbach Youth Foundation, The Steppingstone Foundation and Year Up.

A lifelong resident of Boston, **Matthew Power** is president of the Boston-based Risk Specialists Companies, Inc., an industry leader in the area of unique risk and catastrophic insurance placements. With offices throughout North America, Bermuda, and London, the company generated more than $6 billion in premium sales in 2006. He joined this subsidiary of American International Companies in 1993 and has worked his way up through the ranks. A graduate of the University of Massachusetts, Matt completed post graduate studies at Harvard Business School. He's on several boards, including The New England Council, the Greater Boston Chamber of Commerce and the YMCA of Greater Boston.

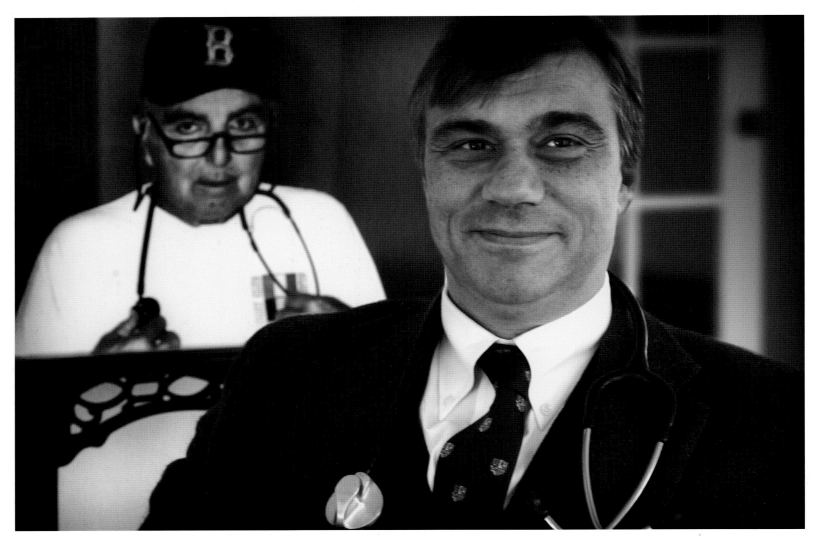

You might think that as a general practitioner **Dr. Laurence J. Ronan** doesn't venture very far from his Massachusetts General Hospital offices. But you'd be very wrong. Larry has traveled the world helping others and now, as the head of the Thomas S. Durant Fellowship for Refugee Medicine, he's ensuring health care professionals have the training they need to serve refugee populations and provide humanitarian aid to victims of disasters. Larry is as modest about his own accomplishments as he is proud of those of the late Dr. Tom Durant, a lifelong Dorchester resident, who provided world-class health care around the globe. It's a torch Larry continues to carry. In 2005, he was part of a 42-member medical team from MGH working with Project Hope on board a US Navy hospital ship anchored off the coast of Indonesia.

Joyce L. Plotkin, president of the Massachusetts Technology Leadership Council, helped nurture and support the software and technology industry in Massachusetts. And while that sounds so very lofty and detached, it's because of Joyce and people like her that our everyday lives have changed for the better. Among the high tech efforts with everyday applications she's worked on are getting the state's computer crime laws on the books and co-chairing both the Boston Wireless Task Force and the statewide Net Day effort that helped to wire almost half of the public schools in the state. She is credited with launching the educational technology revolution in Massachusetts.

Dr. John William Poduska Sr. was there when the computer revolution began: a founder, vice president of research, and director of Prime Computer; the founder, CEO and chairman of Apollo Computer; the chairman and CEO of Stardent Computer; and chairman of the board of Advanced Visual Systems. Although he claims to be retired, this avid pilot and runner is involved in numerous community groups, often spurred by the tireless work of his wife, Susan. The couple fund several projects through the Poduska Family Foundation.

When you're looking at a record of achievement like that of Jack Parker, who has run Boston University's varsity men's ice hockey program since 1973, it's worth scanning the highlight reel. By the close of the 2007 season, Jack had coached his teams to two NCAA titles, 20 Beanpots, and six Hockey East titles. This former BU standout player has led his team to a record 21 NCAA tournament appearances, the most of any active coach. Jack won his 700th game on December 3, 2004. He has been Hockey East Coach of the Year five times and has seen his players go on to great achievements. Eighteen of his players have competed in the Olympics since 1976.

As president and CEO of Tufts Health Plan, **James Roosevelt Jr.** is an outspoken advocate for quality health care. As chairman of the Massachusetts Association of Health Plans and the Mount Auburn Hospital board of directors, and past board chairman of the Massachusetts Hospital Association, he extends his advocacy to the organizations providing medical care. But this grandson of Eleanor and Franklin D. Roosevelt is mindful of his legacy and is a proud Democrat. He has been a delegate at the last several Democratic National Conventions, is chief legal counsel for the Massachusetts Democratic Party and chairs the Democratic National Committee's Rules and Bylaws Committee.

**Charlotte Golar Richie**'s mission is to make sure that Boston's poorest residents aren't lost in the city's often white-hot and erratic real estate market. The chief of housing for Boston, Charlotte advises Mayor Thomas M. Menino on policy, legislation and community relations, and coordinates the mayor's local housing advisory panel. Another cause dear to the former state representative's heart is the city's neighborhoods, particularly Dorchester, which she represented in the state legislature. She also oversees the Department of Neighborhood Development. A former Peace Corps volunteer in Kenya, Charlotte has worked as a newspaper and television reporter.

**John E. Rosenthal** joined Meredith Management Corp. in 1983 and has since grown the business into one of the largest owner-managers of residential properties in the state. Although he's been working to develop an area along Lansdowne Street over the Massachusetts Turnpike, he's probably better known as the owner of the iconic billboard that runs along the Pike that has featured several anti-gun violence messages over the years. John is president of the American Hunters & Shooters Association and is founder of the successful not-for-profit Stop Handgun Violence, Inc. He also founded the nonprofit corporation Friends of Boston's Homeless.

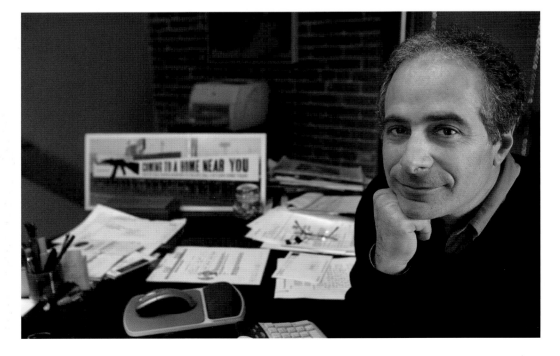

In 1953, bass singer **Herb Reed** got an idea to form a singing group named for the slang used by disc jockeys to describe records. Five years later, The Platters released "Only You (and You Alone)," which was followed by other chart toppers including "The Great Pretender," "My Prayer," "Twilight Time," and "Smoke Gets in Your Eyes." The Platters have sold more than 200 million records. Herb, shown here on a bench dedicated in his name in Winchester, his adopted hometown, has championed the cause of getting legislation passed to protect original groups from imposters and to ensure that the pioneers of the music business get paid for their work.

As attorneys and lobbyists with a keen political sense, these veteran Boston counselors would not likely advise their clients to follow their actions. But **Robert H. Quinn** and **James T. Morris** founded their law firm in 1979 on a handshake. Bob's a former attorney general for Massachusetts, having served in the post from 1957 to 1969. Jim's a former assistant attorney general who later served as counsel to the Speaker of the Massachusetts House of Representatives. Still working as trial lawyers, Bob and Jim don't shy away from politically charged cases. In 2007, they helped the Mashpee Wampanoag Tribe receive federal recognition, ending a 35-year quest.

As founder and chairman of the Mount Vernon Company, **Bruce A. Percelay** is the owner of more than 1,200 apartments in Boston and has gained a solid reputation in the business community. But it is through his civic work, including revitalizing the area's Make-A-Wish Foundation chapter, spearheading the effort to build the new Nantucket Whaling Museum, and leading the Boston area's Habitat for Humanity efforts that you'll find Bruce's legacy. Senator John F. Kerry, in a special proclamation to the United States Congress, said Bruce is "A giver, a doer, a dreamer who has helped rekindle the spirit of community in Massachusetts."

The stylish touches of The Catered Affair are hard to miss at any size event, but **Holly Safford** wouldn't have it any other way. This South Shore company, which Holly runs with her sons, **Alex** and **Andrew Marconi**, has a regional reputation for providing creative entertaining solutions, engaging venue design, delicious food, and—above all else—a meticulous attention to every detail. Equally impressive is the roster of civic and charitable organizations that Holly and her company have supported, which include the Boston Ballet, Christmas in the City, The Epiphany School, the Muscular Dystrophy Association and the Museum of Transportation.

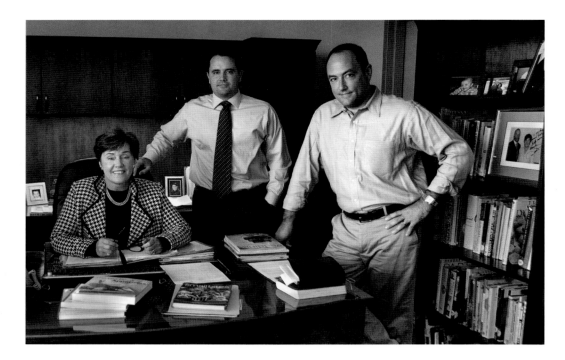

It's been said that in just 11 seconds **Travis Roy** realized his dream only to have it smash into a nightmare. He was a 20-year-old Boston University hockey player in his first game when a freak accident sent Travis into the boards cracking his fourth vertebra, which left him paralyzed from the neck down. As he recounts in his memoir, *Eleven Seconds,* written with *Sports Illustrated* hockey writer E.M. Swift, Travis was determined that his story wasn't going to end there. With the support of his family and friends, he has made physical progress, and through the support of countless thousands he founded the Travis Roy Foundation, dedicated to spinal cord survivors and research.

The eleven Rooney brothers are from South Boston, an area where many large families are famous for being infamous. The Rooneys, however, are well-known for what they've accomplished, not for the misdeeds they done. They are from left **Jimmy, Joe, Larry, Paul, Michael, Chris, Tommy, Buddy, Gerard, Jackie** and **Mark Rooney**— all seated on the Dorchester Heights monument, just around the corner from where they grew up. Missing from the portrait are the real heroes of the story: mom and dad, Peg and Fred Rooney, who raised their sons in the house where Peg grew up. Four brothers went on to graduate from Ivy League colleges; by early 2007 eight were married; and they had more than tripled their number in grandchildren. One's an NHL referee, another runs the Boston Convention & Exhibition Center, another started his own insurance firm, still another has a real estate office and runs SouthBostonOnline.com.

**Gerald M. Ridge** has put as much effort into the Boston Police Athletic League as some businessmen put into their companies. In 1985, Gerry founded and built the local wing of the national network with the help of members of the Boston Police Department and other concerned citizens as a community crime prevention resource. It was the first police athletic league in the state. And the president and CEO of the Boston PAL did this while serving as president of Blue Hill Cemetery and running his GM Ridge Corp., a real estate development company. He's also been active in the Francis Ouimet Society, a special membership group of Ouimet Fund supporters, the Irish American Partnership, and other programs that support education and athletics.

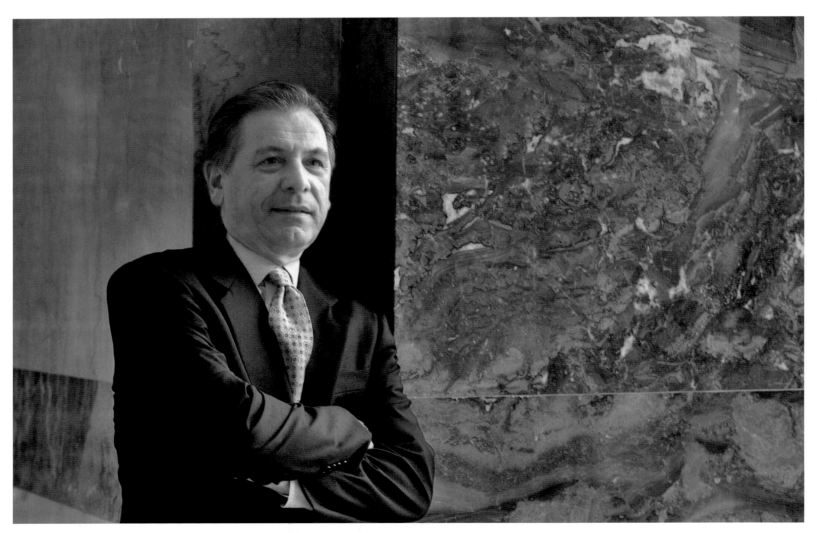

**Ronald E. Logue** is chairman and chief executive officer of State Street Corp., the world's leading provider of financial services to institutional investors. A proud recipient of both a bachelor's degree and an MBA from Boston College, Ron joined the company in 1990 as a senior vice president and steadily worked his way through the upper echelons of the company. Not one to just stay in his Financial District office, Ron serves on several boards including the Metropolitan Boston Housing Partnership and the United Way of Massachusetts Bay, and is trustee of the Museum of Fine Arts.

**Robert L. Reynolds** surprised many in the financial community when in April 2007 he announced he would be stepping down as vice chairman and chief financial officer of Fidelity Investments. While the one-time possible heir to Fidelity's top spot announced he was leaving the Boston-based mutual fund giant, Bob and his wife, **Laura,** showed no signs of pulling up their Boston stakes. He's a former football player for West Virginia University, who would go on to referee college ball. In 2006, Bob was a finalist to be commissioner of the National Football League. An indefatigable volunteer in the Boston area, Laura is on the board of the Boys and Girls Clubs of Boston.

Céilí band leader and Gaelic roots music expert **Larry Reynolds** knows how to move his audience with goltraí (sad songs, laments), suantraí (lullabies) and geantraí (dance tunes). Reynolds, holding a fiddle while hosting a Monday night seisiún at the Green Briar Irish Pub in Brighton, came to Boston via Galway and is a leader in the Irish music scene. Larry is the Boston chairman of Comhaltas Ceóltoirí Éireann, a worldwide organization devoted to the preservation and promotion of Irish traditional music. Reynolds, usually with fiddle in hand and hornpipe at his side, is the anchor for area seisiúns where musicians bearing a broad range of proficiency with their instruments are welcome to play and learn while having a craic—or a good time—as Larry and his fellow players always seem to do.

THE RIGHT TO SUE
AND DEFEND IN THE COURTS
IS THE ALTERNATIVE OF FORCE.
IN AN ORGANIZED SOCIETY
IT IS THE RIGHT CONSERVATIVE
OF ALL OTHER RIGHTS,
AND LIES AT THE FOUNDATION
OF ORDERLY GOVERNMENT.

WILLIAM H. MOODY, 1907

It's been said that everyone in prison claims to be innocent, but **Joseph Salvati** was one of four men falsely convicted for a mob-linked murder they did not commit. After spending 30 years in prison, Joe was paroled in 1997 and later exonerated thanks to WBZ-TV reporter **Dan Rea** and Joe's lawyer, **Victor J. Garo,** who worked on Joe's case pro bono for more than 25 years. Victor pursued the case tirelessly and, with the help of Rea, a veteran Boston reporter who found a witness and documents in support of Joe, the one-time prisoner had his name cleared. In May 2001, Joe and his wife, Maria, and Victor testified before the US Congress about their ordeal. In 2007, Joe was pursuing a civil suit against the FBI, which was found to have hidden evidence that would have cleared the four men rather than expose one of the bureau's informants.

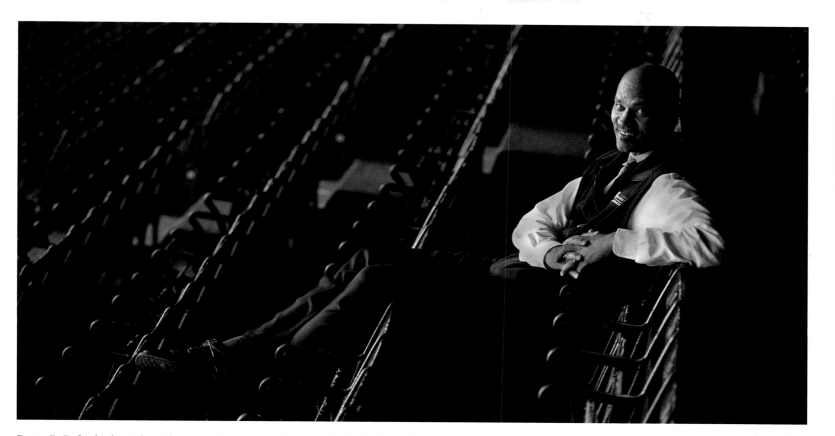

**Peter P. Roby** looks right at home in the seats at Fenway Park. Perhaps that's because the role of sports in our lives and the positive changes that athletics can bring to communities is a major part of this director of Northeastern University's Center for the Study of Sport in Society's philosophy. A regularly referenced expert and published author, Peter is a popular and often featured public speaker who promotes the idea that "the sports community can, and should, take a lead role in bringing about positive social change through research, education, and advocacy." A former vice president for US marketing for Reebok, Peter was Harvard's head basketball coach for six seasons and on the coaching staffs of Stanford, Dartmouth (where he played as a student), and the US Military Academy at West Point. He serves on the boards of a few area nonprofit groups and in 2004 was appointed to the Massachusetts Governor's Committee on Physical Fitness and Sport.

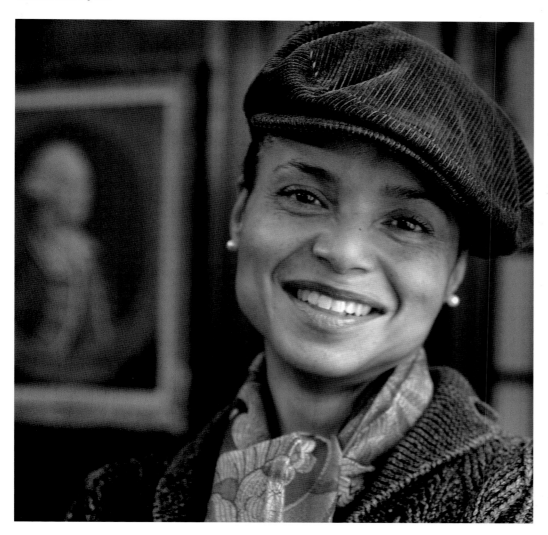

Actress **Victoria Rowell** became a familiar face for her thirteen years on *The Young and the Restless* and costarring in *Diagnosis Murder.* Victoria has been using her star power to speak on human rights. Born in Portland, Maine, Victoria spent her childhood in the foster care system and at age of eight was awarded a full scholarship to the Cambridge School of Ballet. She later became a member of the American Ballet Theater and studied at the Julliard School of Music & Dance. In 2007, Victoria's focus was on completing her book, *The Women Who Raised Me,* and a documentary, *The Mentor,* about the important people in her life who helped her achieve her dreams.

It started as a small show on Boston's public broadcasting station where familiar sounding voices took us to familiar locales and addressed the all-too-familiar problems New England's homeowners faced. Now, the gang from *This Old House* is part of Time, Inc., and they set out around the nation and even beyond to talk about issues people face with their homes. Luckily, the familiar and friendly part still survives. There's general contractor **Tom Silva**, landscaping contractor **Roger Cook**, host **Kevin O'Connor**, master carpenter **Norm Abram**, and plumbing and heating expert **Richard Trethewey**, the one using the toilet as his chair.

What if there was a way to tap into the energy of a city's adult residents to provide educational support to young people? One answer is Citizen Schools, which was founded in 1995 and operates a national network of apprenticeship programs for middle school students, connecting adult volunteers to young people in hands-on learning projects. **Eric Schwarz** is president and CEO of Citizen Schools, who before co-founding the program worked for five years for City Year. **John Werner** is executive director of Citizen Schools Boston, leading nine sites and other programs that serve more than 1,000 young people in Boston. Missing from the photo is Ned Rimber, managing director, a co-founder of the organization.

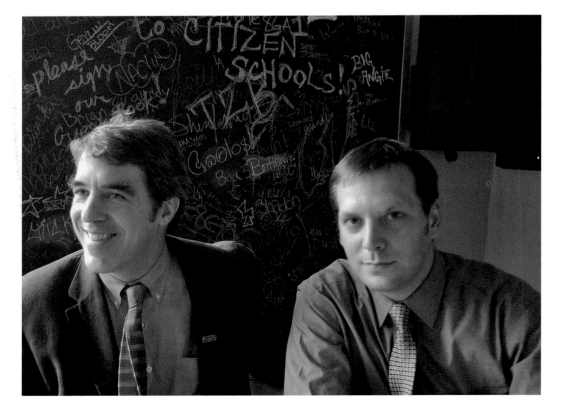

She's been named Businesswoman of the Year by the New England Women Business Owners Association and has been ranked among the most influential women in Boston, but **Lois E. Silverman** is best known for helping other women make the most of their lives. Lois is a former rehabilitation nurse who trained at Beth Israel and went on to found her own company that helped insurers get disabled workers back on the job. And in 2005, Lois became the first woman to serve as chair of the board of the Beth Israel Deaconess Medical Center. She is the founder of The Commonwealth Institute, which supports women by helping them grow their businesses and careers.

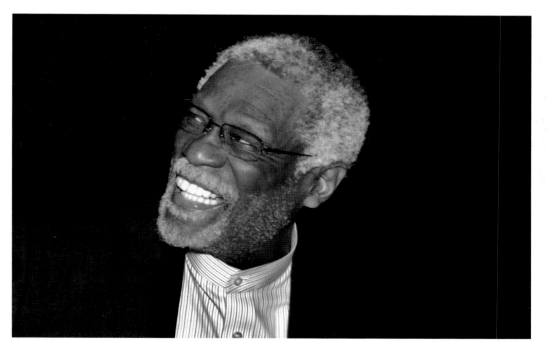

The debate might rage on among basketball fans, but ask anyone in Boston and the answer to the question of the greatest winner of all time is simple: Celtics legend **Bill Russell.** If you need some evidence, just try 11 NBA championships in 13 years—including two as a player/coach. Bill was a 12-time NBA All-Star and the league's Most Valuable Player five times. Before his NBA rookie year he was on the Gold Medal–winning US national basketball team at the 1956 Olympics. In the years since his pro-career ended, Bill has taken on a sort of elder statesman and advisory role for the Celtics and many players in the NBA.

People want to know what **Raj Sharma**'s thinking. As Senior Vice President and Private Wealth Advisor for Merrill Lynch Private Banking Group, Raj has nearly 20 years of experience in financial analysis, corporate finance, and asset management. Raj also is a recognized industry leader, having been profiled in *Money* magazine and several other trade publications. But he doesn't concern himself solely with Wall Street. Raj is co-chairman of Island Alliance, a not-for-profit devoted to the conservation, development, and promotion of the Boston Harbor Islands; is on the Board of Overseers of the Museum of Science; and is on the Leadership Council of the American India Foundation.

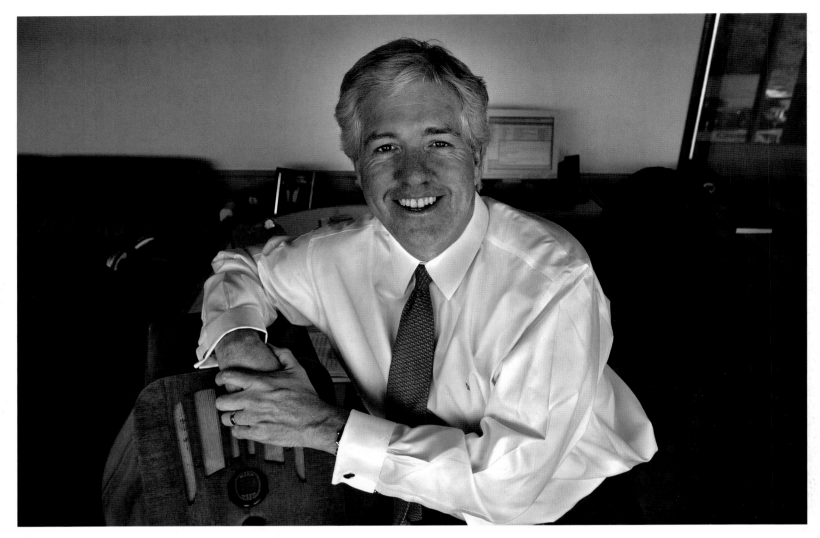

In 1986, **Peter Smyth** joined Greater Media as general manager of Boston's WMJX-FM. He steadily moved up the ranks and was named Greater Media's president and CEO in 2002, overseeing 20 AM and FM stations in several markets. While some companies are known for what they do on air, the company's reputation extends to what they do in the community. There's the WBOS Earthfest that takes place each May; Magic 106.7's Exceptional Women Event, which pays tribute to outstanding women who are making a difference in the community; and Country 102.5's Country Cares for St. Jude Kids Radiothon.

During her 2006 run for lieutenant governor, **Andrea Silbert** was called a voice for the middle class. A former financial analyst for Morgan Stanley who holds three degrees from Harvard, Andrea left the firm to go to Brazil where she worked with street children. She is co-founder and former CEO of the Center for Women and Enterprise, a nonprofit organization that focuses on entrepreneurial training for women and has helped more than 10,000 people launch small businesses in more than 200 communities in Massachusetts and Rhode Island. Although unsuccessful, her run for statewide office was notable. Andrea, who lives on Cape Cod, was the only candidate who hadn't held an elected position.

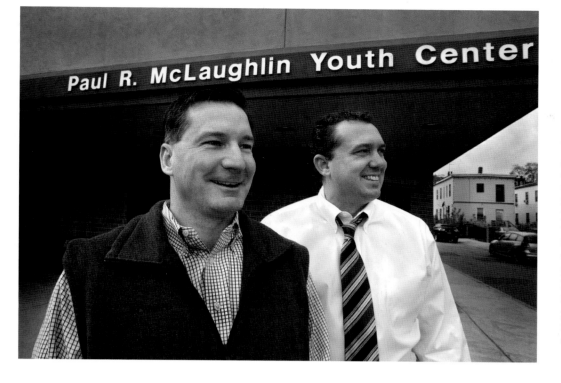

When Paul R. McLaughlin was gunned down by a known gang member in 1995—just a day before the assistant attorney general was set to try his assassin for the third time in a year—that might have been the end of Paul's efforts to fight gang violence and improve the lives of neighborhood youth. But the law enforcement community, Paul's friends and family, and the youths he had served weren't going to let that be. **Bob Scannell,** president and CEO of the Marr Boys and Girls Club, and **Lee Michael Kennedy,** president of Lee Kennedy Company, led the effort to expand the Marr club in Dorchester to include a youth center in Paul's memory that now serves as a beacon of hope and opportunity to its 4,000 members.

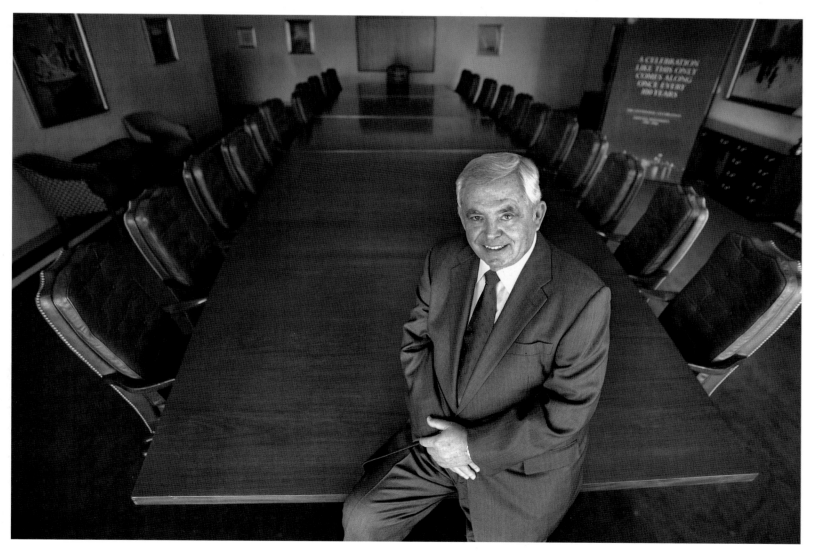

He was first in his Suffolk University Law School class of 1954, but graduation was just the beginning of a more than 50-year history with his alma mater for Suffolk University president **David L. Sargent**. A professor in the university's law school, David later was the school's dean until 1989, when he became president. In 1999, Suffolk named its law school building for him. David has served on several boards and commissions in the state, is a former vice president and board member of the Greater Boston Chamber of Commerce, and is a former member of the board of directors of the Beacon Hill Civic Association.

Reach for the skyline! The cranes controlled by **Bob Marr** and **Jack Shaughnessy** reach the heights of Boston's architecture and infra-structure, delivering people and construction materials daily to projects around and sometimes under the city. Shaughnessy is president and CEO of Shaughnessy & Ahern, founded in 1916, while Marr is chairman and CEO of Marr Companies, 1898. Marr and Shaughnessy are quiet philanthropists who contribute to big and small causes alike. When St. Augustine's Church in South Boston closed, Shaughnessy riggers were there to gently move a 1,200-pound statue of St. Augustine from the steeple and place it at St. Monica's Church where many of the parishioners now worship. Not far away, the Colonel Daniel Marr Boys and Girls Club in Dorchester continues to flourish, as it has become a national model for providing a safe place to learn and grow.

Drug Enforcement Administration New England Special Agent in Charge **June W. Stansbury** asked that her photograph be taken while she was doing the only thing that she believes should be done with illegal drugs—destroying them. She comes by her beliefs through her work in the DEA, which she joined as a special agent in 1983. Her posts have included Detroit and Baltimore, and she holds a doctorate in criminal justice and criminology from the University of Maryland. She is convinced that if we do not destroy drugs they will eventually erode our society. Her motto is: "We must destroy drugs—not the other way around."

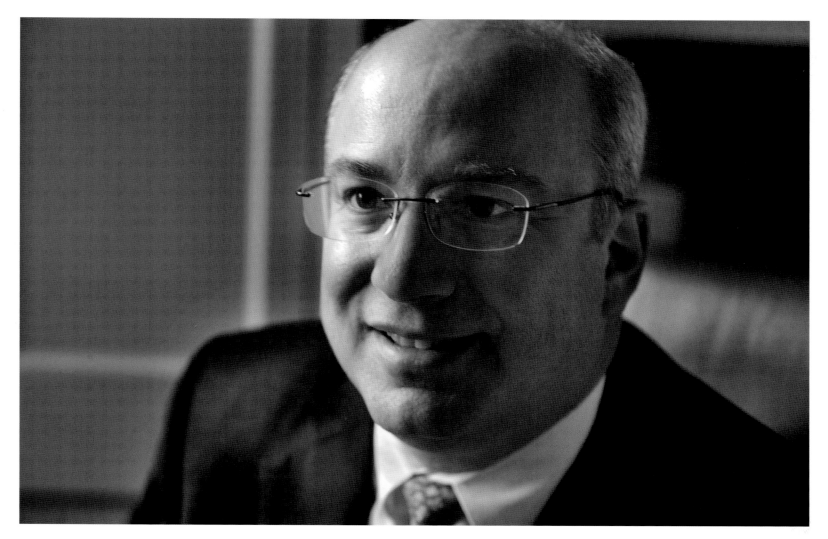

**Dr. Peter L. Slavin,** a physician with an MBA, was CEO and chairman of the board of trustees of the Massachusetts General Physicians Organization when he was tapped to be president of Massachusetts General Hospital in 2003. A Malden native, Peter has spent most of his career at the MGH. Peter's previous roles at MGH include senior vice president and chief medical officer from 1994 through 1997, during which he oversaw the hospital's extensive clinical program, ensuring the quality and safety of medical care and services. He has been a member of the hospital's medical staff since 1987, serving as a primary care physician. Peter also is a member of the medical staff for the New England Patriots.

**Billy Starr** had mapped out a different course for his life. In 1973, fresh out of college, Billy was planning a great travel adventure, but then his mom, Betty, was diagnosed with terminal cancer. He put his plans on hold and stayed in Boston until she died ten months later. Billy tried his hand at different careers before founding the Pan-Massachusetts Challenge, New England's first bike-athon, in 1980. Now, tens of thousands of miles later, with tens of millions of dollars raised for the Dana-Farber Cancer Institute's Jimmy Fund, Billy is executive director of the organization that has become the most successful cycling fund-raising event in the world.

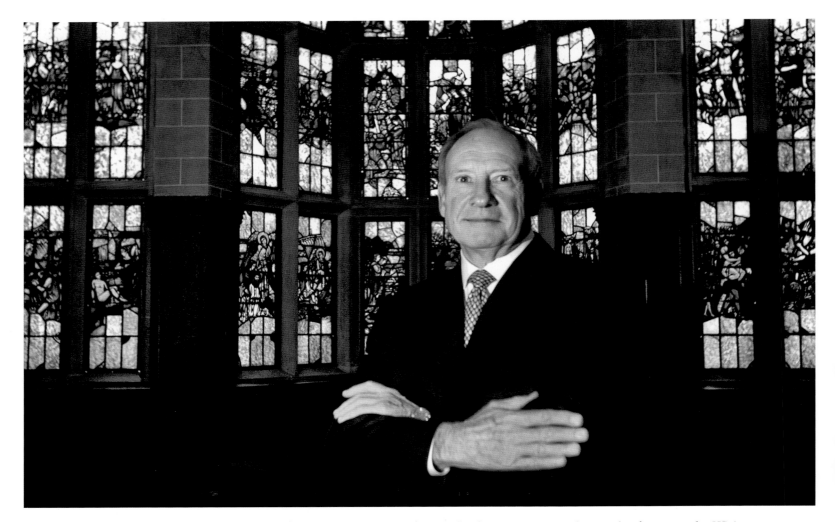

**Patrick T. Stokes** turned a Boston College mathematics degree, an MBA from Columbia University, and a couple of years in the US Army into a 37-year career with Anheuser-Busch Cos., Inc., that is the envy of the corporate world. From starting as August Busch II's assistant in 1972, Pat steadily worked his way up the company's structure to be president in 1990. In 2002, he was named president and CEO of Anheuser-Busch Co. When he retired in 2006, he was elected chairman of the board. Pat always maintained a commitment to civic work and his tether to Boston College, where in 2007 he was chairman of the board of trustees.

The story of the Sullivan family in Cambridge politics is the story of the city's government since the Depression. A seat on the Cambridge City Council has been held by a member of the Sullivan family continuously since 1936 and has been affectionately called "The Sullivan Seat." Upholding the family's tradition today is **Michael A. Sullivan** (Mayor 2002–2006, City Councilor 1994–present, Clerk of Courts 2007–present), center, standing in front of a portrait of his grandfather, Michael A. "Mickey the Dude" Sullivan, City Councilor 1936–1949 and father of the two men flanking his namesake. At left is Mayor Emeritus **Walter J. Sullivan** (Mayor 1968–1970, 1974–1976, 1986–1988; City Councilor 1960–1994), Michael's father. At right is Walter's brother **Edward J. Sullivan** (Mayor 1956–1958, City Councilor 1949–1960, Clerk of Courts 1959–2007.) In 1986, the city renamed the council's meeting room as the Sullivan Chamber in honor of the Cambridge family's service. It was at that event that Walter and Edward's portraits were hung, joining their father's, which had been part of the chamber for years.

Singer-songwriter-guitarist **James Taylor** has played out his life to music and given listeners an intimate peek into his life over the last four decades. But there's an irony in his career, James admitted to a *Boston Globe* interviewer in late 2006, because he's truly a very private person and a reluctant pioneer. Still many people feel they know the father of four, who has young twin sons with his wife Caroline "Kim" Taylor. Perhaps that's because so many of us listen to his music and mark time by his numerous hits. James has five Grammy Awards (from his second album "Sweet Baby James" to "October Road" in 2002) and has more than three dozen gold, platinum or multi-platinum designations. Born in Boston, James continues to remain tethered to the city and his beloved baseball team, the Red Sox. He's also an ardent supporter of the Boston Symphony Orchestra and has performed at Tanglewood in Lenox, where he set the attendance record of 24,470 at a concert with the Boston Pops in the summer of 2002. The concert drew such traffic that the BSO agreed to cap all future concerts at 18,000.

Most people don't give their tires much thought; thankfully, Sullivan Tire and Auto Service founder **Bob Sullivan** and his son, company owner **Paul Sullivan**, and his brothers do. The sons built the garage Bob founded in 1955 into a locally based 43-shop chain with locations in Massachusetts, New Hampshire, Rhode Island, and Maine. They have more than 800 employees of which 161 have been with the company for 10 years or more. All the success reflects Bob's belief that the company should "treat everyone, customers and fellow employees, as you would a member of your family."

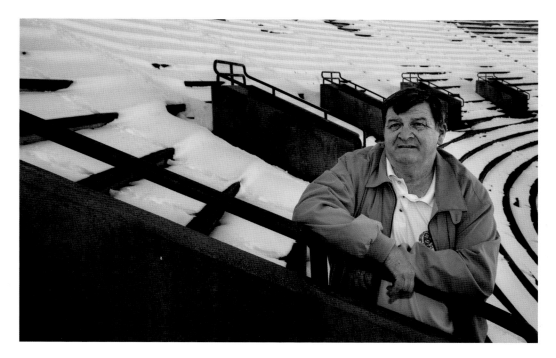

During his 30 years of running the equipment room in the Dillon Field House, **Chet Stone III** did about as much to ensure Harvard's athletic programs were ready for action as any other. He started an alumni and friends annual golf tournament, now known as the Chet Stone Dillon Open Golf Tournament, to raise money for Children's Hospital and St. Elizabeth's Hospital in Brighton. Although he retired in 2005, Chet continues to reach out to the Allston-Brighton community by providing tickets to Harvard sporting events to area youth and arranging the use of the university's facilities. Chet is working with the company that is developing the South Weymouth Naval Air Station.

He is a manager known for taking on difficult tasks, and **Lewis H. (Harry) Spence**'s five-and-a-half-year tenure as the commissioner of the state's Department of Social Services was marked by his commitment to the communities he served. In March 2007, Harry traveled to Harlingen, Texas, where dozens of parents had been taken by federal authorities after an immigration raid at a New Bedford factory. A Harvard-trained lawyer, Harry had served on some high-pressure jobs before. He was deputy chancellor for operations for the New York City Public Schools, and receiver for both the bankrupt city of Chelsea and the Boston Housing Authority.

As president of the Benjamin Franklin Institute of Technology, **Michael Taylor** has a mandate to ensure that the students attending the South End institution not only advance themselves but benefit society. If those goals sound lofty, it's because the school's mission was set out in the will of Benjamin Franklin. Appreciative of the technical training he had received, Franklin wanted to make sure those coming after him had the training and skills they needed to advance themselves. This is something Michael takes seriously, as do all those working at and attending the post-secondary school that offers several degree programs.

There must be something funny in the region's water supply. Comics **Steve Sweeney** and **Seth Meyers** have made people laugh in every conceivable format—radio, television, film, internet—and by performing live. Steve's performed on stages around the country and is a regular at the Boston area's biggest clubs. Seth has appeared on more than 100 episodes of "Saturday Night Live" and has several movie credits under his belt. The two worked together in April 2005, entertaining some 900 guests who had gathered for the Red Sox Foundation Welcome Home Dinner to celebrate the World Champion Red Sox and raise money for the team's foundation.

No one can accuse Citibank of being shy. The financial institution marked its entry into the Boston area by announcing a 15-year partnership with the Citi Performing Arts Center, formerly the Wang Center for the Performing Arts, a nonprofit arts organization and theaters. Leading the bank's charge into the retail marketplace is North Shore native **Tim Sullivan**, who spent seven years as a pilot in the US Marine Corps where he was a captain serving in Operation Desert Storm and other conflicts. Tim oversaw the opening of Citibank's first branch in the Back Bay in September 2006 with several more following in quick succession.

As Red Sox pitcher **Curt Schilling** used crutches to make his way into the State Room in November 2004 to thank the supporters of his charitable organization that raises money to find a cure for Amyotrophic Lateral Sclerosis—also called Lou Gehrig's Disease—it was his famed right ankle that was the center of attention. As he and wife, **Shonda,** passed through the crowd and thanked those who had worked to help raise $460,000 on behalf of his Curt's Pitch for ALS that year, fans and friends could be heard yelling, "How are you feeling?" and "How's the ankle?" The pitching ace for the recently minted World Series champions, who still had ten stitches in his leg, assured the crowd that he would be all right and turned his attention to more pressing matters such as raising money to find a cure for ALS. "I just hope that they understand every dollar they give, we are one dollar closer," Schilling said at the event.

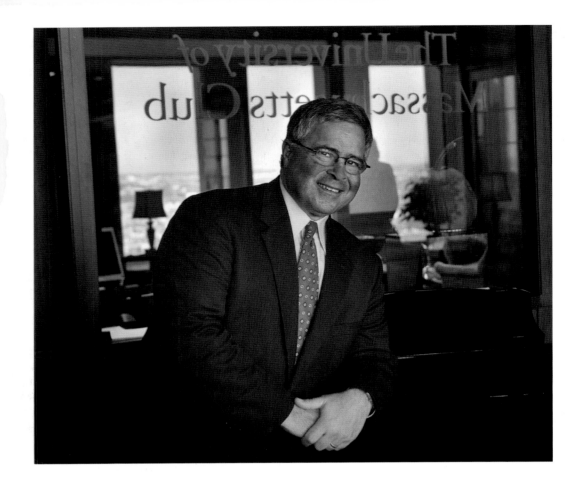

**Stephen P. Tocco** is president and CEO of the consulting firm ML Strategies, but that's only a sliver of what keeps him busy. In fall 2006, Steve became the chairman of the University of Massachusetts board of trustees and had just finished a term as chairman of the Massachusetts Board of Higher Education. A former CEO of Massport and state secretary of economic affairs, Steve also served as special assistant to governors William F. Weld and Paul Cellucci. Although he's been a manager and leader in the state, Steve started out on a different path. He holds a bachelor's degree in pharmacy and chemistry from the Massachusetts College of Pharmacy.

He was the director of the Boston Redevelopment Authority when Mayor Kevin White was in office, but **Robert F. Walsh** still serves as a sounding board for the business community and Mayor Thomas M. Menino on development issues. He founded his own company, RF Walsh Company, Inc., in 1980 and served as chairman and CEO until late 2006 when he sold the business. Not one to retire, Bob still works as a consultant. As chairman of the Trust for City Hall Plaza, Bob was an outspoken advocate of not only keeping space available to the public, but for finding ways to fund it for future generations.

There must have been something in the water at the Thomas family's house—perhaps it was the fluoride. **Dr. Edwin Thomas** started his dental practice in Mattapan in 1948 and was a pioneer in championing comprehensive dental health. Since then, his four sons have followed in his footsteps. They are from left, **Dr. E. Michael Thomas,** an endodontist, **Dr. Brian R. Thomas, Dr. Richard K. Thomas,** and **Dr. Kevin M. Thomas.** The family is involved in the community and supports a host of charitable causes. One cause, however, is particularly dear to the Thomases. The brothers host an annual golf tournament to raise money for cancer research in the name of their brother, Gary, who died while studying to be a dentist at Georgetown University.

He's an internet innovator and founder of Monster.com. He's a marketing whiz and branding expert who is a much sought-after speaker. Yet there's one thing **Jeff Taylor** cannot do—participate in Eons, the web community he's created for those over 50. The Needham native is a boomer but hasn't passed the milestone that he says is the next great frontier. That hasn't hurt the success of his latest venture, which counts actress Jane Seymour as an adviser. "Age is the only thing that's not debatable," Jeff said. "There's been this belief that you can't talk about age, but that's just not true." 123

**Douglas Tillinger** started as an entrepreneur when he was 22 years old. Now the president of Tillinger's Concierge, Doug hasn't lost his enthusiasm for succeeding in business and making people's lives better. He says he's infatuated with the "art of service," and strives to ensure his company provides genuine concierge services to real estate owners and managers at residential and commercial properties. Doug's hospitality services company also is among the area's largest event planners and operates a function-facility management and personal-errand services divisions. Doug and his company don't just help those living the good life, they regularly assist nonprofit organizations to help those less fortunate through pro bono fundraising assistance and in-kind donations.

*The New York Times* used **John Updike**'s own words to describe the novelist, short-story writer, poet, essayist and critic as "one of the chief glories of postwar American literature." A 1954 summa cum laude graduate of Harvard, John sold a poem and a short story to *The New Yorker* magazine that same year. A few years later, he moved to Boston's North Shore, and the area that has served as the setting for several of his 60 books has been his home ever since. When he received his second Pulitzer in 1991 for *Rabbit at Rest*, John was only the third American to win the prize twice in the fiction category. He received the National Medal of Art in 1989, and in 2003 was presented with the National Medal for the Humanities.

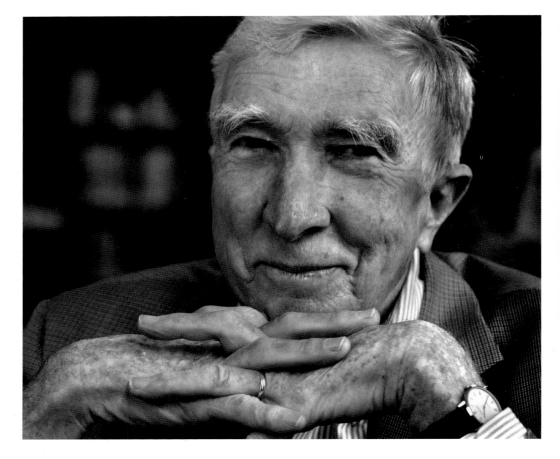

In 1963 **David T. Ting** came to the United States in search of the American Dream. Like other immigrants before him, David worked hard and made the best of the opportunities presented to him and has earned his way to a respected position in Boston's business community. As president of Mugar Enterprises Inc., David directs a globally diversified portfolio of public and private investments. David says that his gratitude for what he has been given is a motivating force to give back to the community whenever he can. He is a trustee at Beth Israel Deaconess Medical Center and the chairman of its Finance Committee. David also serves on the boards of WGBH Educational Foundation and South Cove Nursing Foundation.

Born in Boston and raised in the western part of the state where her father was a professor at Amherst College, actress **Uma Thurman** hasn't forgotten where she came from. The *Pulp Fiction* star was in town in November 2006 to host the first Boston fundraiser for Room to Grow, a nonprofit that helps some 200 area low-income families each year—particularly mothers and their babies. Uma became involved with the organization when she was expecting her first child. "These are people in our communities, who stay in our communities," the actress said. "We can solve this. We can make lives better."

With film and television credits piling up, it's easy to forget that **Jonathan Moss Tucker** got his start at a young age in Boston Ballet's "The Nutcracker." His dad is UMass Boston art professor **Paul Hayes Tucker.** An authority on Monet, Paul was a guest curator for the Museum of Fine Arts, blockbuster show "Monet in the '90s." The Tuckers are standing in front of "Huru,"a 55-foot steel abstraction by Mark diSuvero. It was the first piece installed for Arts on the Point, a public contemporary sculpture park Paul created on campus. Jonathan had just finished filming *In the Valley of Elah* with Oscar-winner Paul Haggis when he was called in May 2007 to go to Australia to shoot *Ruins*.

To most of the city they are Boston's premier power couple. But if you ask them, **Suzy** and **Jack Welch** are prouder of some more common titles: parents, civic leaders, and huge Red Sox fans. The couple writes a weekly "The Welch Way" column for *Business Week* that is syndicated in *The New York Times* and 40 other newspapers. Both teach: Jack's at MIT's Sloan School of Management; Suzy's at Babson College's Center for Women's Leadership. His speaking engagements take them around the world and she's on the staff of *O, The Oprah Magazine*. Jack, a former General Electric CEO, occasionally does color commentary on NESN, and Suzy is a mother of four. The Welches have become involved with Boston Health Care for the Homeless, where she is co-chair of the capital campaign. Other programs that benefit from their civic commitment include the University of Massachusetts system (Jack's an alum), Salem State College, and the Salem Boys and Girls Club.

With a repertoire of 15,000 songs and a promise that they can learn any tune—if given enough time and the sheet music—**Bill** and **Bo Winiker**'s orchestra are the city's most steady entertainers, even earning the title "Boston's House Band" from *The Boston Globe.* Among their many gigs are a few that were landmarks in the city's storied history: the opening of the Faneuil Hall Marketplace, the closing of the Boston Garden, the 125th anniversary of the Museum of Fine Arts, and the 150th anniversary of the Boston Public Library.

In a state that prides itself on a high concentration of high-quality higher education, President **Jack M. Wilson** takes great pride in the state's public university system. Joining him in leading the University of Massachusetts campuses and upholding that more than 140-year tradition are the system's chancellors, who are shown here before a reorganization was announced. They are: next to President Wilson in front, **Jean F. MacCormack,** University of Massachusetts Dartmouth. Left to right on the stairs are **William T. Hogan,** University of Massachusetts Lowell, who retired in 2006 and has been replaced by former US Congressman Martin T. Meehan (not pictured); **Michael F. Collins, MD,** University of Massachusetts Boston; **John V. Lombardi,** chancellor and professor of history at the University of Massachusetts Amherst, who announced his retirement in May 2007; and **Aaron Lazare, MD,** chancellor and dean of the University of Massachusetts Medical School in Worcester, who announced his retirement in March 2007.

As soon as he sets foot on Yawkey Way, the "El Tiante!" chants reverberate off the walls of Fenway Park. **Luis Tiant**, a major league pitcher for 18 years who spent from 1971 to 1978 in Boston, remains among the most popular players to have ever worn a Red Sox uniform. And this Cuban-born, famously flamboyant right-hander who once said that "family is everything; it is more important than baseball," has had a full life after hanging up his cleats. Fans can eat El Tiante's food at a booth at Fenway. He has a line of El Tiante Cigars. And he has served as a commentator on Red Sox home game broadcasts on Spanish-language radio. Of his adopted hometown, Luis said: "When I'm in Boston, I always feel like I'm home. I almost cry, I feel so good."

As co-managing partner of Foley Hoag LLP, **Michele A. Whitham** has worked to ensure that Foley Hoag remains a leader of community-involved, publicly responsible companies. The firm supports a long list of organizations and has set up the independently governed Foley Hoag Foundation, dedicated to the improvement of race relations in the Boston area. Among the causes this active litigator has personally championed is the tragedy of homelessness in an affluent society. A member of the board of Shelter, Inc., Michele has served as its president and helped transform the agency from one providing temporary shelter for families to one that builds permanent housing.

**Michael Winter** is senior managing director of Bear Stearns Co. in Boston, but in 2006 he was better known to many as husband of **Deborah Goldberg**, candidate for lieutenant governor. The end of the campaign was not the end of public life for this civic-minded couple, who founded the Center for Career and Lifelong Learning at Jewish Vocational Service. Michael's causes include Children's Hospital, Northeastern University's Center for Family Business, and Combined Jewish Philanthropies. Deb is chair of Adoptions With Love, founder and treasurer of Berkshire Hills Music Academy, and an Overseer of Planned Parenthood League.

When the delivery arrives, we need only see the trademark "W" to know that something beautiful from Winston Flowers is inside. From their warehouse on Southampton Street, brothers **Michael, Ted,** and **David Winston** are the third generation to oversee the company. In its 50 years, Winston Flowers has grown to one of the largest retail florists in the country, with an 80,000-square-foot design studio. The company has 250 employees and averages 5,000 deliveries per week. For Valentine's Day and Mother's Day weekend those numbers will jump to 15,000 deliveries and 100 extra seasonal employees.

Like the majestic structure behind them, **Benaree "Bennie" Wiley** and **Carol Fulp** are bridges within Boston's communities, linking people and programs at all levels. Like the late activist Leonard P. Zakim, whose name graces the span that echoes the Bunker Hill Monument, these women reach out to different segments of our society. In 2005, Bennie stepped down from running The Partnership Inc., which works with professionals of color. She is now a social and civic entrepreneur. Carol is the vice president of community relations at John Hancock Financial Services, where she oversees the corporate giving program ensuring that Boston youth who are most in need are served.

If Nyctea, an 8-year-old male snowy owl, looks comfortable on **Marcia Wilson**'s arm it's because he has developed a trust for the founder of Eyes On Owls, an enterprise that brings people face to face with these fascinating creatures that are often right in our backyards. Like the fourteen other owls in Marcia's care, Nyctea has a disability that prevents him from being released back into the wild. Often called "The Owl Lady," the renowned naturalist and owl rehabilitator has state and federal permits to use these birds as educational ambassadors. She has given programs before an estimated 200,000 people.

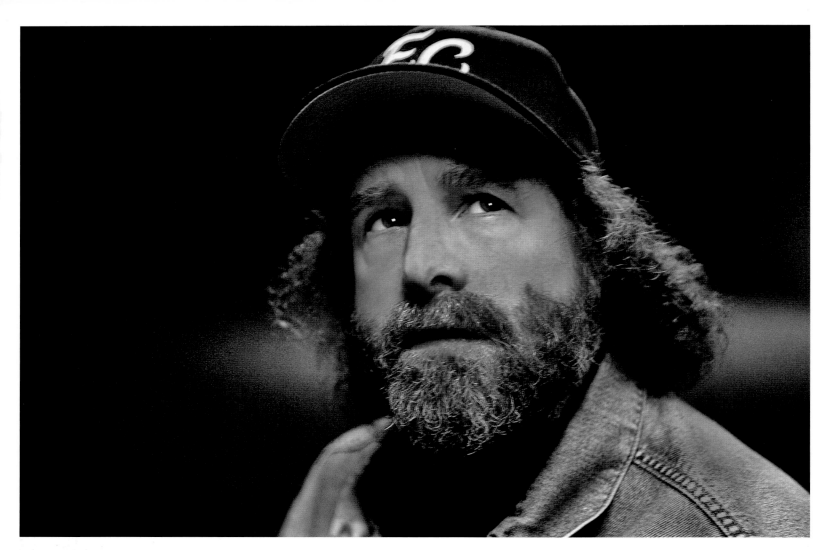

We confess we don't always get him either. But there is no one funnier than **Steven Wright**. A standup comic, Steven won an Oscar in 1989 with Dean Parisot for the live-action short film "The Appointments of Dennis Jennings." He attended Emerson College with fellow area funnyman Denis Leary, has some two dozen film credits to his name, has appeared in nearly a dozen television shows, and still does standup when his schedule allows. Although born in New York, Steven was raised in Burlington and is a devout Red Sox fan, appearing in the television documentary *Reverse of the Curse of the Bambino*.

It's been said that there are only six degrees of separation between you and anyone in the world. In Boston, it's more likely three steps, but to get to the power brokers in the city you'll likely need one of these women from the city's public relations ranks to serve as your sherpa. One's a former fashion flack who has turned her handwritten address book into a resource for international nonprofit groups. Another is a former television anchor who is as recognizable as the utility company for which she works. Gathering for a little networking—what else?—at the Four Seasons Hotel they are: **Doris Yaffe**, far left, and up the staircase **Marlo Fogelman, Ann Carter, Kelley Chunn, Nancy Sterling,** and **Wendy Pierce.** Down the steps from left are **Helene Solomon, Geri Denterlein, Sandy Lish,** and **Carmen Fields.**

When the homeless men and women on the South Shore need a place to go where they can get out of the elements, grab a warm meal, and have a safe place to sleep, they know they can find those necessities that most of us take for granted at Father Bill's Place in Quincy. Executive Director **John Yazwinski** oversees the operations at the interfaith agency started in 1984 by **Rev. William McCarthy**, Father Bill himself. Through state budget cut backs and other difficulties, Father Bill's Place soldiers on. "I take the Gospel seriously," Father Bill told a *Boston Globe* columnist. "Whatever you do to the least of my brothers, you're doing to me."

Since taking the top post at the Mattapan Community Health Center, **Dr. Azzie Young** has overseen a 40 percent jump in patient volume and a budget that has increased by 50 percent. A former research scientist with Polaroid Corp. and an assistant professor of chemistry at Boston University, Azzie has a master's degree in public policy from Harvard's Kennedy School of Government and holds a master's degree and a doctorate in organic chemistry from the University of Nebraska at Lincoln. She worked for 15 years in Kansas state government, but for more than a decade her focus has been on the Blue Hill Avenue health center that treats more than 7,000 people each year.

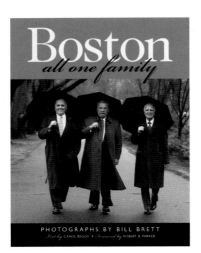

Boston Mayor Thomas M. Menino (center) and his predecessors, former mayors Raymond L. Flynn (left) and Kevin H. White, gathered for this photograph in the Public Garden. With more than 40 years of Boston leadership between them, the three mayors have led the city in very different times and have face very different challenges, but each has continued to be a strong voice for the city and its people.

PHOTOGRAPHS BY BILL BRETT

# AFTERWORD

*Boston, All One Family* was so titled because I felt it portrayed the people of Boston as family working for a common good. This second book is also about family—an "extended family."

I dedicate this book to one wonderful, outgoing Bostonian who throughout his entire life walked the streets of this great city with a big smile on his face, saying hello to everyone he met. Never did he recognize who was rich or poor, good or bad. A true Bostonian, Jack Brett, fondly known as "JB," is my oldest brother. The role of an older brother is to teach you things. Some may say the biggest lesson he taught us was how to overcome obstacles. For Jack there were many, because he was born mentally challenged. However, I think his biggest gift has been his love of life and people. This he instilled in me. JB, this book is like your own story. It is made up of people who went beyond what many others thought they could do. It is about the unique personalities of Boston who continue to achieve success and participate in the community in a positive way. It is with great love that I dedicate this publication to you. Thank you for showing me the way.

I also want to extend my gratitude and love to my wife, Ginnie, for her unwavering support; my children, Megan, Erin, Tim, with special thanks to Kerry, also a photographer, who served as my picture editor on this project; my granddaughter, Morgan; my grandson, Greyson; my sons-in-law Doug Hurley, John Khayali, and Corey Gunter; my other brothers, Jim, a great advocate for special needs, and Harry, a photographer extraordinaire; and my sisters, Margaret and Mary. Thank you for your love and support.

Special thanks to my dear friend David Mugar who is always there to support me. David has for thirty-four years shown his love for Boston on the Fourth of July. In addition, thanks to RJ Valentine, who is always there to motivate and encourage.

Mike Casey, who started out as my student and assistant, has now graduated at the head of the class. AnneMarie Lewis Kerwin helped plan and coordinate all of the shoots. My deepest gratitude goes to my first and finest teachers, Don Bulman and Danny Sheehan. You will always be in my thoughts.

Many thanks to fellow photogs Ted Gartland, Jim Wilson, and Pulitzer Prize–winning idol Stan Grossfeld and to image technicians/photographers Jim Bulman, Susan Chalitoux, John Iovan, Kathleen Johnson, Janine Rodenshiser, and Director of Photography Paula Nelson.

I also must mention Tom Mulvoy, Mike Barnicle, Ed and Bill Forry, John McDermott, Mark Shanahan, John Burke, Kathleen Cable, Alan Henning, Leah Putman, David Ting and Erin McDonough, Gerard, Ruth, Justin and Jamie Adomunes, Bobby Devine and Jeff Lazzarino, Deva Amonte, Jack McCormack, Ted Weyman, Steve Owens, Dr. Larry Ronan, Dan Marr III and Justin Holmes. A special thanks to Hallmark Institute of Photography graduates and digital artists Melinda Thao, Kat Kattler and Chris Rioux, who helped greatly with the production, and to Harry Werlin, Hugh Devine, and Bill and Eddie Balas. The governors shoot would not have been possible without the help of Peter Flaherty and Nancy Sterling.

Thanks to the staff of Commonwealth Editions, including Webster and Katie Bull, Diana McCloy, Anne Rolland, Jill Christiansen, Perry McIntosh, and Carol Mendoza. Again, Carol Beggy has stepped up to the plate with her time and talent to make this book a success. My sincere thanks.

*Bill Brett*
*May 2007*